ANNE LYLES AND DIANE PERKINS

COLOUR INTO LINE
Turner and the Art of Engraving

THE TATE GALLERY

cover
T. HIGHAM AFTER J.M.W. TURNER
Ely Cathedral, Cambridgeshire 1833, detail
(cat.no.21)

ISBN 1 85437 027 8
Published by order of the Trustees 1989
for the exhibition of 4 October 1989–21 January 1990
Copyright © 1989 The Tate Gallery All rights reserved
Designed and published by Tate Gallery Publications,
Millbank, London SW1P 4RG
Typeset in Monophoto Baskerville
Printed by Balding + Mansell plc, Wisbech, Cambs
on 150gsm Parilux Cream

EXHIBITION SPONSORED BY

Contents

Foreword

The large body of reproductive engravings after Turner's work consti-
tutes the most neglected area of his output. The fact that it was executed,
for the most part, by other men has obscured the importance of his own
contribution to it. In reality, it may be said that engraving was Turner's
primary means of communication with the public at large. His paintings
were seen by those who visited the exhibitions of the British Institution
and the Royal Academy; the private gallery that he opened in
Marylebone was a bid not so much to increase that audience but to
expand his own opportunities for putting his wares on display. But by
means of the illustrated topographical tour or souvenir Annual he could
demonstrate his powers to everyone with access to a library. He was
aware of the possibilities of engraving as publicity from the earliest
moments of his career, and by the time he was thirty was embarking on
one of the most comprehensive exercises in publication ever mounted by a
great artist – the *Liber Studiorum*. For this he frequently etched the subjects
himself, and the ultimate consequence of the project was the 'Little Liber
Studiorum', a set of mezzotints he executed in the 1820s to express some of
his grandest and most personal ideas, and which are probably the finest of
all romantic mezzotints. The mass of designs that he made in the 1820s
and 30s to illustrate the poetry of Milton, Byron, Scott, Campbell and
Rogers testifies to his well-established relationship with the engravers
whom he had carefully trained to interpret every last nuance of his subtle
art.

At the time of his death, none of the prints, not even the 'Little Liber',
were counted among the original works by his hand which came to the
Nation as the Turner Bequest. Hence the Tate Gallery possessed only
very few examples when the Clore Gallery opened in 1987. But in view of
their obvious importance in any comprehensive collection of the artist's
output, it was felt vital to establish a representative holding in the Clore
Gallery; the series of proofs for the *Southern Coast* acquired by Lord
Tweedmouth and later owned by members of Turner's family is a
particularly important feature of this new archive. A virtually complete
collection is held by the British Museum, and fine examples are to be
found in many places elsewhere, notably in the Victoria and Albert
Museum and at University College, London, and, in America, at the
Boston Museum of Fine Arts and the Yale Center for British Art.

Nevertheless, it is important that those who enjoy Turner's work at the Clore Gallery should be aware of its complementary holdings of engraved material. This exhibition is designed to draw attention to them and provide a survey and assessment of this neglected but fascinating aspect of his achievement. Further illumination will no doubt be shed by Professor Herrmann's forthcoming book (see Bibliography).

The authors of the catalogue would like to thank all those who have offered help in any form, especially William Drummond, Antony Griffiths, David Penn, Lindsay Stainton, Rosalind Turner and Hilary Williams. We are also grateful to British Gas North Thames for their generous sponsorship of the exhibition.

<div style="text-align: right">Nicholas Serota Director</div>

Introduction

Great as his achievements were as painter and watercolourist, Turner was best known to the public of his own day through engraved reproductions of his work. During the course of his long career, nearly nine hundred prints were made from his designs, almost all by professional craftsmen trained in the arts of engraving. Although some of these prints reproduced Turner's oils, they were mostly made from watercolours painted specifically by him to be translated into engraved form, whether for topographical series or as illustrations for literature.

Turner was well aware of the role engravings could play in popularising his work. The great art critic, John Ruskin, is only the most famous example of the many from his generation who must have first come to know Turner's work through engraved reproductions (see under cat.no.64). But Turner also realised that engravings could serve as a vehicle for communicating his ideas. The *Liber Studiorum*, for example, planned and mostly published by the artist himself in the earlier part of his career (see under cat.no.30), was intended to function as a kind of visual treatise for the promotion of his ideas about landscape art. Indeed, printmaking was seen by Turner as one of the greatest channels of communication available to the British artist, and one in which he wished his own work to be judged. In a letter of 22 June 1822 to the print publisher J. Robinson (of Hurst and Robinson), Turner discussed their proposal to issue four large line engravings after his paintings[1]. He hoped that the prints after his work would 'bear up' with the celebrated engravings by William Woollett after the classical landscapes of Richard Wilson published by Boydell in the 1760s; 'to succeed', Turner wrote, 'would perhaps form another epoch in the English school'. Although this particular scheme came to nothing, the project initiated twenty years later for five large plates after Turner's oils (see cat.no.87) was clearly conceived in a similar spirit.

It is undoubtedly significant that the *Liber* and the late large plates of 1842, both intended to promote Turner's status and that of British printmaking in general, were funded by the artist himself (the five large plates were published by his agent, Griffith, on Turner's behalf; see under cat.no.87). Both projects would have involved a large outlay of capital which, as Turner must have realised from the outset, would have been difficult to recoup. Indirectly such schemes were subsidised by the many other, more lucrative engraving projects on which the artist embarked

throughout his career and where he did not undertake the financial risk. He was often paid considerable sums for the watercolours he was commissioned to make for various topographical series – twenty-five guineas for each of those for the *History of Richmondshire*, for example, and thirty for the designs for *Picturesque Views in England and Wales*. (However, later in his career Turner chose to loan rather than sell his watercolours to the publishers; those for Rogers's *Italy* and *Poems*, for instance, were hired out for five guineas each). Moreover, the artist's income from these projects can only have been augmented by his own sharpness in money matters, for the various stories of Turner's meanness emanate more from his engravers and publishers than almost any other section of his acquaintance. Indeed the question of remuneration, whether that which Turner received from the publishers or that which he was prepared to give his engravers, led to a number of bitter quarrels; for example with the mezzotint engraver Charles Turner in 1809 (see under cat.no.30), and with the engraver-publisher W.B. Cooke in the mid-1820s, perhaps contributing to the demise of two of the latter's projects at that time, the *Rivers of England* and *Marine Views* (see under cat.nos.41–3).

Despite such difficulties, however, there was never a shortage of publishers eager to commission work from Turner, confident that his participation would ensure the success of their ventures. The economics of print-publishing tended to dictate that much of the initial capital should be supplied in advance by subscribers to the work in question, which would then be issued in parts, ideally at regular intervals to maintain their interest and confidence. Nevertheless many of the projects to which Turner contributed designs were abandoned before completion. Sometimes they came to grief because they were envisaged on too lavish a scale from the start, as seems to have been the case for the *Richmondshire* series; at other times they appear to have suffered competition from smaller, cheaper publications, or simply failed to attract subscribers, as with *England and Wales*. But external market forces also had an impact. The crash of December 1825,[2] for example, bankrupted the publishing firm Hurst and Robinson, who had put up the initial capital for *England and Wales*, and the project could easily have been abandoned before a single print had been published had not Robert Jennings stepped in to save the day. While many of the volumes of poetry and prose by popular authors which Turner illustrated in later life were on the whole a financial success, it is significant that those for Samuel Rogers were underwritten by Rogers himself who was prepared to spare no expense in the illustration of his own verse.

Most of the series of prints after Turner's work were executed either in

line-engraving or in the tonal medium of mezzotint. Line-engraving was still regarded in the early nineteenth century as the best and most prestigious medium for the printmaker. Although at the beginning of Turner's career the technique was passing through a rather uninspired period in its history, it was to prove in the hands of more proficient and sensitive engravers the ideal medium for capturing all the hallmarks of Turner's style – the luminosity, brilliance and intricate detail which characterises so much of his mature work. On the other hand mezzotint, for all the skill of its practitioners, proved in the long run too broad and dark a medium for the translation of Turner's ideas (see under cat.no.42), although in combination with etching it worked well for the *Liber Studiorum*.

The nature of Turner's enquiring mind and the experimental approach he brought to bear on all forms of artistic activity meant that it was all but inevitable that he should at some stage take up printmaking himself. In fact, from a very early age he showed an interest in printmaking techniques, copying down a recipe for an etching ground on the back of a study made at the Academy schools and listing in a sketchbook the etching equipment he might need.[3] In 1791 he seems to have been planning to engrave and publish a series of 'Twelve Views on the River Avon'; and an early soft-ground etching, almost certainly by Turner himself, has recently come to light in the Bequest.[4] Although he never attempted line engraving, a technique traditionally tackled only by professionals, Turner was to try his hand at most other printmaking processes then known to the engraver. During the years between 1807 and 1819 when the *Liber* was in the course of publication, for example, he not only developed and refined his knowledge of etching and soft-ground etching, but also experimented with two other, tonal, processes of printmaking, aquatint and mezzotint (see under cat.nos.33–4 and 37–8; he also appears to have been interested in lithography, but apparently did not practise this method). Mezzotint, which he learned to handle with great accomplishment during these years, seems to have held a particular appeal for Turner on account of its rich, painterly effects and dramatic chiaroscuro (qualities which were later to make it attractive to Constable, who adopted it for his *English Landscape Scenery*). Turner was to explore these effects most fully in the prints of the 'Little Liber' series (see under cat.nos.48–55), his only sustained performance as a printmaker on his own account, and indeed his last personal foray into printmaking.

When one considers the crucial role played by colour in Turner's art, it has sometimes been seen as rather puzzling that so few coloured prints were made from his work during his own lifetime.[5] Yet the reasons for this

are probably not very hard to find. Most coloured prints in Turner's time, whether printed in colour or coloured by hand (or a combination of both), were aquatints. The printseller Rudolph Ackermann, for example, who opened premises in the Strand in 1796, stocked a wide variety of fashionable literature embellished with coloured aquatints.[6] Despite its popular appeal, however, aquatint was not regarded as highly as other printmaking methods such as mezzotint and line-engraving; Farington, for example, referred to aquatint as a 'low branch of art'[7] and Turner chose mezzotint rather than aquatint for the *Liber Studiorum* from the outset (see under cat.no.30). Turner may have regarded aquatint as too crude a method for reproducing the technical complexities and conceptual richness of his work, particularly his mature watercolours which translated so well into line-engraving, and especially into black and white. His most important experiment with colour printing took place early in his career, when he supervised the printing of a number of coloured impressions of the 'Shipwreck' plate, and drew up a special contract with the engraver, Charles Turner, to ensure that they would be under his own 'direction' (see cat.no.28). Even then, Turner failed to prevent coloured impressions being taken without his permission, an experience likely to have made him suspicious of the business of colour printing in general, although eight years later he collaborated again with Charles Turner when the latter engraved the only other colour mezzotint after his work, 'The Burning Mountain', reproducing an oil painting of 1815 (B&J 132; an impression of this rare print is in the British Museum).

In 1807, at the very time the coloured impressions of the 'Shipwreck' were being issued, the engraver, John Landseer, father of the famous animal painter and a colleague of Turner's, was drawing attention to the imperfections of colour printing in his *Lectures on the Art of Engraving, delivered at the Royal Institution of Great Britain*.[8] These *Lectures*, a copy of which Landseer presented to Turner, formed part of the campaign which Landseer was then leading for the full recognition of engravers at the Royal Academy, denied them since its foundation in 1768. One of the arguments which Landseer put forward as a justification for their higher status was that engraving, far from being merely a copying process, was rather one of translation: 'Engraving is no more an art of copying Painting', he wrote in his *Lectures*, 'than the English language is an art of copying Greek or Latin'.[9] Although Turner, like other members of the Academy Council, seems to have remained essentially unmoved by the engravers' bid for full academic recognition (on the contrary it has been argued that his involvement in the *Liber* rebutted their claims since he was appropriating their skills himself[10]) he does seem to have sympathised

with their arguments. Indeed in the draft notes he made for one of his perspective lectures around 1810, he wrote in similar vein that 'Engraving is or ought to be a translation of a Picture, for the nature of each art varies . . . in the means of expressing the same objects'.[11]

If, then, painting and engraving were independent methods of expression with their own, separate vocabulary, it followed that any engraver would have to exercise judgment as well as skill in interpreting Turner's work. Over the years Turner succeeded in creating a 'school' of engravers, about eighty in number, sympathetic and responsive to his requirements while nevertheless allowing their individual artistic personalities to flourish. Once selected, often while still young, these engravers would be subjected by Turner to a rigorous course of training; for he would frequently anotate their proof impressions (especially in the early years) with a barrage of touchings, instructions, comments or diagrams (see especially under cat.nos. 1–7 and also cat.no. 12). Turner himself had an extraordinarily fine sense of the balance of light and shade in his work: it is said that, on seeing a proof lying upside down on a table some distance away from him, he was able to diagnose the tonal faults and prescribe the remedy without needing to turn the print round.[12] And as Turner corrected his engravers' work, so he himself learned how most effectively to draw and paint with a view to translation into black and white – a gloss on Ruskin's comment that Turner 'paints in colour, but he thinks in light and shade'.[13]

Indeed, in the 1820s Turner became increasingly preoccupied with the relationship of colour to black and white. The old systems of chiaroscuro had relied on the tonal range between black and white; most late eighteenth-century watercolours, for instance (including much of Turner's earliest work), were closely adapted to the needs of the engraver both in their linearity and in their chiaroscuro, layers of grey wash being applied over detailed underdrawing to establish the pattern of light and shade before the addition of minimal local colour – hence their title 'tinted drawings'. By Turner's time, however, such an approach to chiaroscuro was already being questioned, and colour theorists like George Field began to assess colour values themselves in terms of tone.[14] If for the *Liber* Turner made preliminary drawings in monochrome, his later watercolours for the engraver functioned as expressive works of art in their own right, with fewer obvious concessions to the engravers' needs. Preliminary designs such as those for the 'French Rivers' series or his vignette illustrations to Rogers and other poets, became on the one hand less linear and lacking in detail and yet bolder and more saturated in colour. Paradoxically, the less Turner adapted his preliminary designs to

the engraver, the better and more sensitive their interpretations became. For he had succeeded in forcing his engravers genuinely to 'translate' his work so that, as he himself had wished, 'lines become the language of colours'.[15]

It has been argued that Turner, following in the steps of artists such as Raphael and Rubens, was the last of a great line of supervisors of engraving,[16] his achievement being to have trained up an entire generation of engravers capable of translating his work with the insight that only he as overseer could provide (it is significant that after Turner's death in 1851 the engravings made after his work failed to reach the same standards; see under introduction to cat.nos.86–8). Certainly the unique relationship established between artist and engraver, and the close collaboration on which the quality of these prints depended, was not to be seen again after Turner's lifetime. The prints made after Turner's work are both reproductions and translations; they served to reproduce his pictures for a wider audience but they also communicated the quality and message of his art. With the advent of photography in the 1850s, however, the reproductive role of the print was to be usurped either by the photograph itself or by prints produced by photomechanical processes. The future lay instead with the 'original' print, conceived and executed by the artist himself, and invested with a new expressive and creative status. The prints made after Turner's work are too readily seen through twentieth-century eyes, and regarded as mere 'reproductions'. It is hoped that this exhibition will help their true function and superlative technical qualities to be better understood.

Footnotes

(for abbreviated references, see Bibliography)

1. Gage, 1980, no.97
2. Shanes, 1979, p.10
3. On the verso of TB V D and in the cover of the *Studies near Brighton* sketchbook (TB XXX) respectively
4. See Wilton, 1987, p.28; on a sheet of paper divided into two, TB XXXII C and TB XXXII F
5. See Gage, 1969, pp.47–8
6. Richard T. Godfrey, *Printmaking in Britain*, Oxford, 1978, p.80
7. *Ibid*, p.81
8. Gage, 1969, pp.50–1; see especially 'The Third Lecture', pp.181–4

9. Quoted Gage, 1988, p.11
10. *Ibid*
11. Draft for second perspective lecture, British Museum Add. MS 46151, given as Appendix I in Gage, 1969, pp.196–7
12. *The Spectator*, 28 February 1874, p.268, quoted Dyson, 1984, pp.58–9
13. Quoted Pye & Roget, 1879, p.8
14. Gage, 1969, p.51; see also J. Gage, *George Field and his Circle*, exhibition catalogue, Fitzwilliam Museum, Cambridge, 1989
15. See note 11
16. Bell, 1903, p.i

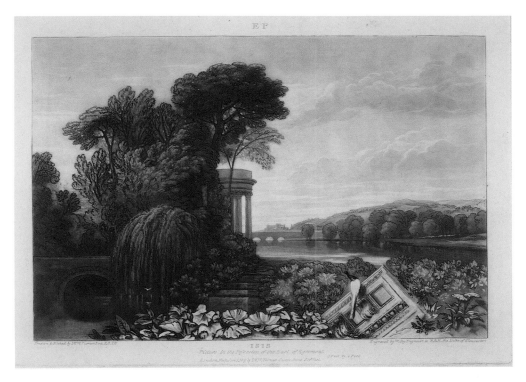

35 **Isis** 1819

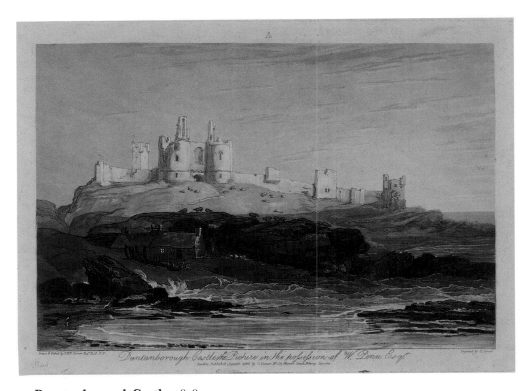

30 **Dunstanborough Castle** 1808

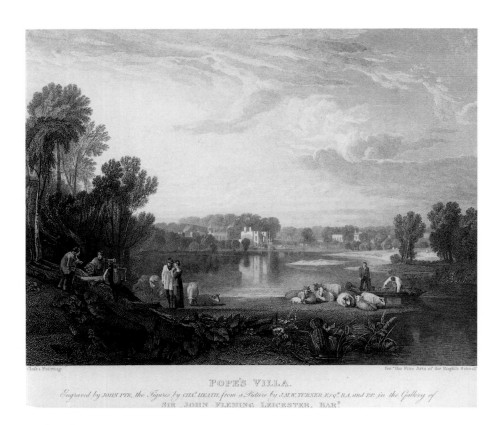

POPE'S VILLA.

Engraved by JOHN PYE, the Figures by CHA.ˢ HEATH, from a Picture by J.M.W. TURNER ESQ.ᴿ R.A. and P.P. in the Gallery of
SIR JOHN FLEMING LEICESTER, BAR.ᵗ

11 **Pope's Villa** 1811

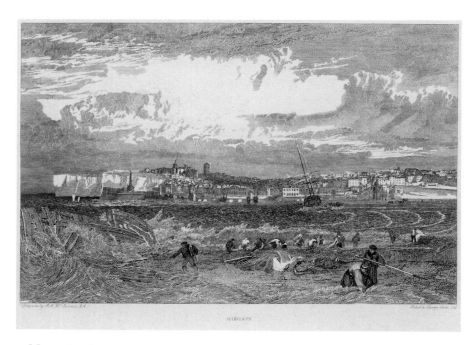

MARGATE

4 **Margate** 1822

15 **St. Agatha's Abbey, Easby: colour study** *c*.1818

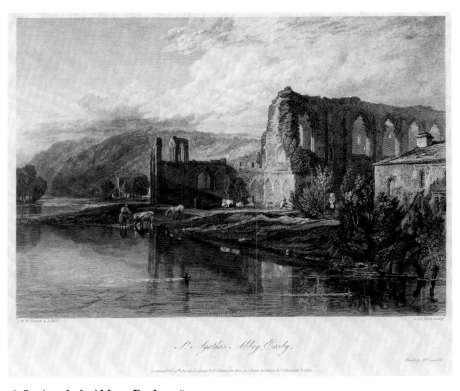

16 **St. Agatha's Abbey, Easby** 1822

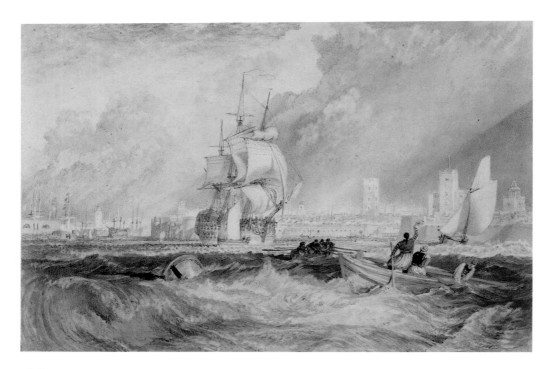

46 **Portsmouth** *c*.1824

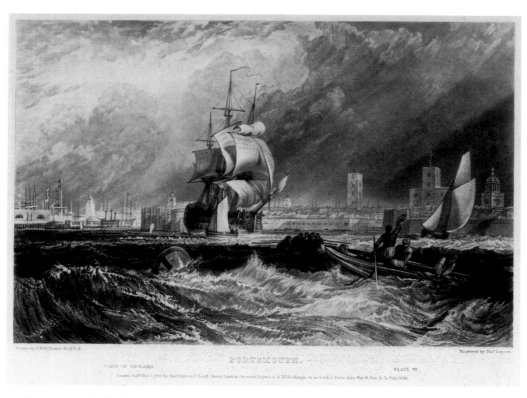

47 **Portsmouth** 1828

49 **Shields Lighthouse** *c.*1826

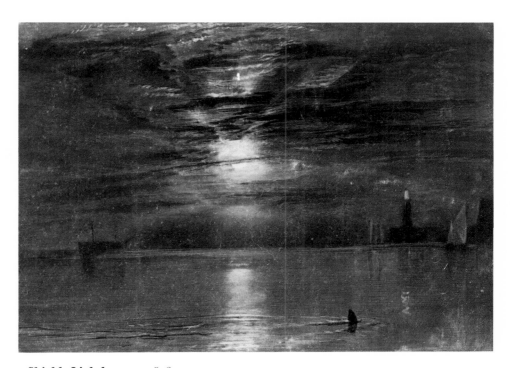

50 **Shields Lighthouse** *c.*1826

67 **Land Discovered by Columbus** *c.*1832

68 **Land Discovered by Columbus** 1834

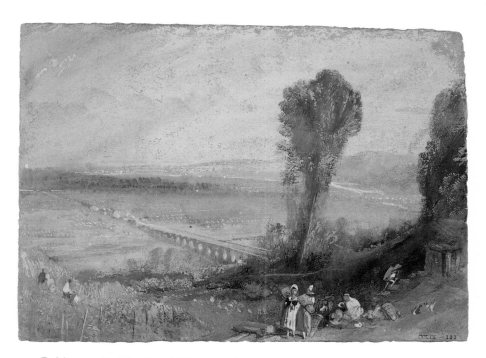

25 **Bridges at St. Cloud and Sèvres** *c.*1832

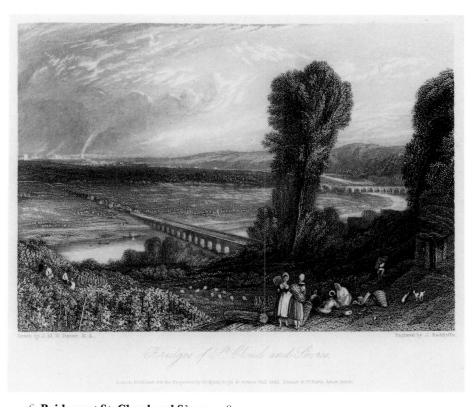

26 **Bridges at St. Cloud and Sèvres** 1835

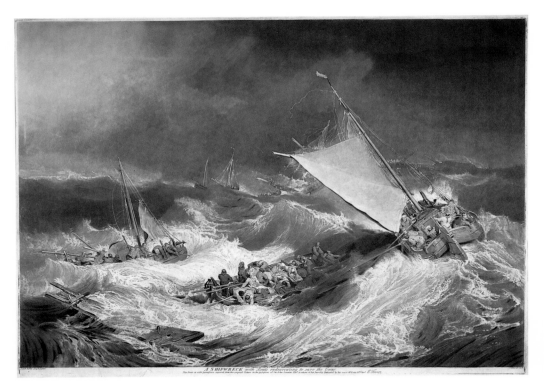

28 **A Shipwreck** 1807 Detail

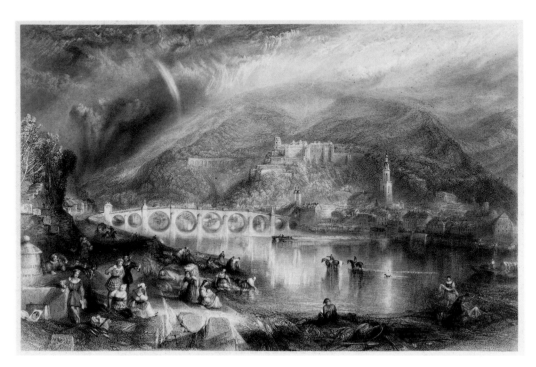

88 **Heidelberg from the Opposite Bank
of the Neckar** 1846

Catalogue

If not otherwise stated, all works are by J.M.W. Turner. All measurements are given in millimetres, height before width. For prints, the image size is given first, followed by paper size (for prints on india paper, the dimensions of the whole sheet are given) and plate-mark when appropriate. The spelling of titles follows that on the prints themselves: inscriptions are given only when by Turner himself; they are invariably in pencil.

Works illustrated in colour or in a larger size are marked *

Abbreviations

B&J Butlin, Martin and Evelyn Joll, *The Paintings of J.M.W. Turner*, 2 vols, 1984 (revised edition)

R. Rawlinson, W.G., *The Engraved Work of J.M.W. Turner, R.A.*, 2 vols, 1908–13

R.L. Rawlinson, W.G., *Turner's Liber Studiorum*, 1878 (1st edition)

TB Finberg, A.J., *A Complete Inventory of the Drawings of the Turner Bequest*, 2 vols, 1909

W. Wilton, A., *The Life and Work of J.M.W. Turner*, 1979, catalogue of watercolours

For other published material which is abbreviated in the text, see Bibliography.

ENGRAVING TECHNIQUES
(cat.nos.1–7)

Cat.nos.1–7 have been chosen specifically as examples of the different printmaking techniques, or stages of the engraving process, which were used by Turner and his engravers. This section is intended to give a brief summary of these printmaking methods, together with their technical terms which are adopted throughout the catalogue.

The vast majority of prints executed after designs by Turner were printed by 'intaglio' methods where the paper receives the ink from lines incised in the metal plate rather than from the surface of the plate. It is therefore the opposite of 'relief' printing (such as woodcut) where the areas to be printed are those which have not been cut away on the block. The intaglio methods used by Turner's engravers were primarily etching and engraving.

Translating the Design

An accurate outline tracing or copy of Turner's composition in watercolour (or occasionally, oil) was made by the engraver. In many cases, the pencil tracing or copy had to be squared down to reduce the scale of the image. The outline was then transferred to the metal plate, usually in reverse so that once the plate had been engraved, the printed image would be in the same direction as the original.

The Plates

Until the early 1820s, most engravings were executed on copper plates. Although the relative softness of the metal made work easier for the engraver, the plates wore down quickly, producing only about a hundred really fine impressions, and the engravers had to rework the plates frequently during the course of printing.

In c.1820, steel plates were introduced (see cat.no.57) which were much harder than copper and were, commercially, an unqualified gain for line-engraving since their durability meant that far more impressions could be taken from the plate. The use of steel for small, delicate engraving work had been encouraged by the activities of the bank-note engraver Jacob Perkins in 1819 and it proved to be ideal for work such as book illustration. Initially, Turner was against the use of steel, fearing that the higher yield would devalue his work; but these misgivings proved unfounded and, by 1830, steel was used for most of his smaller prints and eventually for large subjects as well (see cat.no.88).

Engraving

Although the term 'engraving' is used generally to describe intaglio processes, it specifically refers to the method of incising the lines on the metal plate using a burin or graver, a sharp tool which the engraver pushes away from him along the surface of the plate, gouging out a V-shaped line. It is employed in conjunction with a burnisher to rub down and thus lighten certain areas or remove unwanted lines. Such faults could be corrected by beating out the area in question from the reverse of the plate, which could then be reworked with the burin or burnisher. The engraving itself was very laborious work but perhaps the most skilled and difficult aspect of the task was the translation of what was usually a coloured, tonal drawing into line. Engraving was a method of printmaking primarily undertaken

by professionals and consequently not attempted by Turner, who was otherwise eager to experiment with the different techniques himself.

Etching

The plate is covered while hot with a thin layer of 'ground' (usually composed of waxes, gums and resins) which is allowed to cool and harden. The design is then drawn on the ground with a fine point, the 'etcher's needle', exposing the metal beneath. The lines are then 'bitten-in' by dipping the plate in to acid, which eats into the lines that are exposed. Lines may be 'stopped-out' with varnish to leave them fine, while deeper lines required to carry more ink are left in the acid for longer.

Etching is used for a variety of purposes in the prints after Turner; to put in the broad outlines as the preliminary stage to engraving (see cat.no.1) or, after the adoption of steel plates, to execute the fine lines of almost the entire plate (see cat.no.57). Large open areas of the design (such as the sky), could be etched after drawing in the lines mechanically on the etching-ground with the aid of a ruling machine. Etching as used in the plates after Turner (and by Turner himself, for example, in many of the *Liber Studiorum* prints), is therefore very different from 'artist's etching' as practised by painters like Rembrandt, Claude or Goya where the artist would draw freely on the plate, thus creating an original work of art to be printed. The final 'engravings' are in fact a combination of both etching and engraving. The differences between lines which have been etched and those which are engraved are often difficult to distinguish, but on the whole the etched lines have a greater freedom and have blunt, rounded ends whereas the engraved lines which have been cut as a 'V' shaped groove, taper at the ends.

fig. 1 Detail (enlarged) of cat.no.21, showing the difference between an etched and an engraved line: the girls' pinafores are engraved, and the background is etched

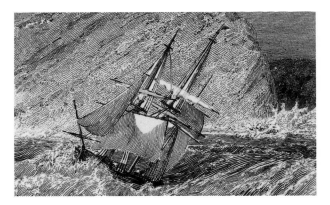

fig. 2 Detail (enlarged) of cat.no.1, showing preliminary etching before later work in fig. 3

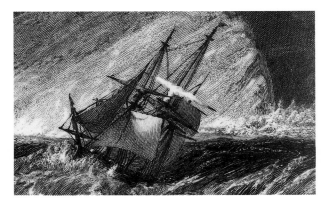

fig. 3 Detail (enlarged) of cat.no.3, showing the published state of fig. 2 with addition of engraved lines

Soft-Ground Etching

The soft ground laid on the plate is a mixture of ordinary etching ground and tallow. It does not harden on cooling as an ordinary etching ground does. The etcher draws on a piece of thin paper placed over the ground so that when the paper is removed, the ground adheres to the paper where the drawing instrument was pressed, leaving the metal exposed. A granular line is thus produced when the plate is bitten and soft-ground is a useful means of imitating a pencil or chalk drawing (see cat.nos.6 and 39).

Aquatint

Aquatint is essentially a form of etching which can be used to imitate the tonal appearance of watercolour washes. The plate is covered with a ground of powdered resin which is fused to the surface by heat. It is then immersed in 'aquafortis' (nitric acid), which bites tiny, uneven rings around each resin grain, thus creating a network of pits in the plate which, when inked, prints as an even area of tone. Gradations of tone can be achieved by 'stopping-out' with varnish; the darker the tone required, the longer and therefore deeper the biting. Aquatint is usually used in conjunction with etched outlines.

fig. 4 Detail (enlarged) of cat.no.30, showing the characteristic aquatint grain

Over twenty aquatints after Turner's work were executed, essentially as a basis for colour printing for which the method is particularly suited (see introduction to cat.nos.12–14). Since Turner was very wary of experimenting with coloured impressions of his work, he produced few important plates by this method. However he did use aquatint in combination with other techniques, most notably in some of the *Liber Studiorum* plates (see cat.nos.30, 32 and 37).

Mezzotint

Although mezzotint is a tonal method of printmaking, it differs from aquatint in its ability to render strong contrasts of light and shade (chiaroscuro), producing dense and painterly effects. Throughout the eighteenth century it had usually been employed in the reproduction of portraits, such as those by Sir Joshua Reynolds; its use in interpreting landscape in the nineteenth century was something of an innovation. Notwithstanding, mezzotint, along with engraving and etching, was the other main method of printmaking used to translate Turner's designs. Although occasionally used on its own, most notably for the 'Little Liber' series (cat.nos.48–55), it was usually used in conjunction with an etched outline such as for the *Liber Studiorum* (cat.nos.30–40). Turner also supervised an experiment in printing a colour mezzotint (see cat.no.28).

The surface of the plate is roughened using a toothed 'rocker' which throws up tiny points or burrs of metal which will hold the ink when printed. If an impression is taken from the plate at this stage, it will print an even, velvety black. The engraver removes the burr using a scraper or burnisher in proportion to the lightness of tone required, thus working from dark to light, the white areas occurring where the burr is completely removed.

fig.5 Detail (enlarged) of lower right-hand section of cat.no.53, showing the texture of lines made by the mezzotint rocker

Other Printmaking Methods

Turner must have been interested in lithography for he owned a copy of Alois Senefelder's 1819 *Complete Course in Lithograpy* and made several notes on the process in his *Brighton and Arundel* sketchbook (TB CCX). Lithography, invented by Senefelder in 1798, was a new type of

process, known as a 'surface' or 'planographic' method, and was based on the principle that grease and water repel each other; it was particularly useful for imitating drawing since the image could be sketched freely on to a stone or plate so long as a greasy medium was used. Only one lithograph, a 'View of Leeds' (R.833), was executed in Turner's lifetime although several plain, coloured and chromo-lithographs were made after his death.

The Printing

Once the etched or engraved plate has been prepared, it is inked and the surface wiped clean with coarse muslin so that the ink remains only in the lines or hollows. A damp sheet of paper is laid over the plate which is placed in the press and printed under pressure in order to force the paper into the grooves to pull out the ink. The intaglio method of printing causes the metal plates to wear down, more as a result of the vigorous wiping of the plates than of the heavy pressure of the press. The resulting print has a plate-mark where the paper has been moulded around the plate; this mark is a distinctive feature of all intaglio prints. However, many engravings published as book illustrations bear no plate-mark; they were produced on large plates, despite the image being small, in order that the impressions could be trimmed down within the plate-mark to the size required for the book.

Impressions, Proofs and States

The individual prints or 'impressions' would appear in a variety of 'states' – each state marking a distinct phase in the development of the print. The earliest are known as 'proof' stages, a term which generally refers to prints before publication. The impressions taken during the execution of the print to see how the work was progressing are known as 'Trial' or 'Engraver's Proofs' although the latter term is also applied to the earliest, high quality proofs after completion of the plate which were the perquisites of the engraver. There are often several different stages of Engraver's Proofs since Turner would add his alterations at this stage; those which he annotated are known as 'touched' proofs. These early Engraver's Proofs are those most sought after by collectors, particularly for engravings on copper or mezzotints since these are often the only ones in which their quality is fully apparent.

Most engravings after Turner were printed on wove paper but some early impressions were taken on very thin, strong paper, known as India paper or *papier Chine* which was particuarly suitable for picking up the fine details from the plate; these are known as 'India Proofs'.

The published impressions of a plate were often reworked between each state or are distinguishable by the different size or variety of the paper. Many of the published engravings after Turner were reprinted, often several years later, occasionally by unscrupulous printsellers who would continue to issue prints long after the plates had worn out; for this reason, Turner sometimes bought back the plates from the publishers so as to uphold the high reputation of the prints after his work (see cat.no.7).

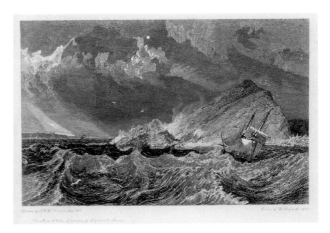

WILLIAM BERNARD COOKE (1778–1855) AFTER J.M.W. TURNER

1 **The Mew Stone. Entrance of Plymouth Sound** 1815
for *Picturesque Views of the Southern Coast of England*
Etching (R.97): 160 × 240; 294 × 438; 227 × 303
Engraved inscriptions: below, with title, artist's name and *Etched by W.B. Cooke 1815*
T05392

An outline etching such as this represented the first stage in the preparation of a print. Once Turner had produced the original composition (in this case, the watercolour of 1814, now in the National Gallery of Ireland; w.454), an etched outline of the design would be made which is known as the 'outline', 'preliminary' or 'open' etching. The broad outlines would be laid in prior to the tone being built up with fine engraved lines.

The lettering below the image on the plate is an important clue to differentiating between the various proofs or states of a print since it was often altered after each reworking; in this case, the words 'etched by . . .' were altered to 'engraved by' after the engraved lines had been added (see cat.nos.2 and 3).

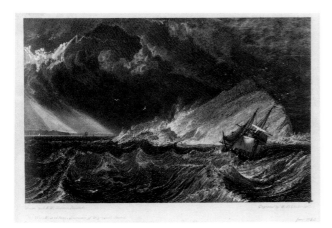

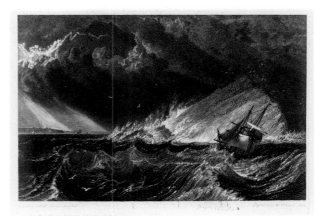

W.B. COOKE AFTER J.M.W. TURNER

2 **The Mew Stone. Entrance of Plymouth Sound** 1815
for *Picturesque Views of the Southern Coast of England*
Engraving, touched first state (R.97): 159 × 240;
190 × 265 (trimmed within plate-mark)
Engraved inscriptions: below, with title, names of
artist and engraver and date
T04384

W.B. COOKE AFTER J.M.W. TURNER

3 **The Mew Stone. Entrance of Plymouth Sound** 1815
for *Picturesque Views of the Southern Coast of England*
Engraving, first state (R.97): 161 × 240; 292 × 446;
228 × 302
Engraved inscriptions: below, with title, names of
artist and engraver and date
T05393

Since Turner's engravings were not simply 'reproductions' of the original watercolours but were intended to be works of art in their own right, the early impressions had to be touched and reworked to convey the effects he desired. Some of the *Southern Coast* prints passed through as many as four or five 'touched proof' stages before Turner was satisfied that the print was ready for publication; even after the first published state had appeared, further alterations were not uncommon.

This print has been 'touched' by Turner in order to explain, in a clearly visual way, the alterations and improvements he required the engraver to make. He has touched certain areas in white chalk, either as a means of adding further detail, such as an increased volume of spray to the water around the rock, or to indicate that certain areas, for example, passages in the waves and sky, should be lightened; an alternative means was to scratch out the details or areas to be lightened, as has been done here to put in the lower seagull. Adjustments have also been made, unusually in brown ink, both to the masts and sails on the boat as well as to add some dots giving more detail to the rock.

This is the first published state of 'The Mew Stone' and it is clear that Turner's touchings have been followed extraordinarily closely by the engraver, perhaps most noticeably in the spray. The end result has far more light and shade and heightened sense of drama than the original watercolour, with the waves splashing higher and the increased emphasis of the boat tossed on the waves giving a feeling of the Sublime. Turner's close involvement and direction of all stages of production of the prints therefore allowed him the opportunity of putting his own artistic stamp on the work.

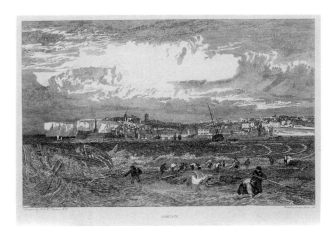

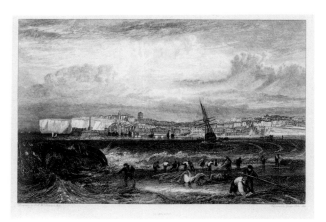

Georation Cooke (1781–1834) after
J.M.W. Turner

4 **Margate*** 1822
for *Picturesque Views of the Southern Coast of England*
Etching, touched, on india paper (R.113):
158 × 240; 269 × 405; 230 × 305
Engraved inscriptions: below, with title, names of
artist and engraver and date
Inscribed by Turner: with pencil sketches in
margin, 'Chalk Cliff', 'Sands', 'Bathing Houses',
?'Flatland'
T05224

Turner's annotated proofs often included small pencil
sketches in the margins, clarifying details which had
only been hinted at in the original watercolour. His
original design for this print (now in the Yale Center for
British Art; W.470) was evidently not sufficiently de-
tailed to be interpreted by the engraver and Turner has
therefore added pencil sketches to this proof which
develop his treatment of the shoreline; he also provides
annotations such as 'Bathing Houses' and 'Chalk Cliff'
to ensure that all the details will be thoroughly
understood by the engraver.

The Cookes must have appreciated Turner's under-
standing of the process and his clear instructions for,
during the execution of the *Southern Coast* series, they
also asked him to touch the proofs of their prints after
other artists.

George Cooke after J.M.W. Turner

5 **Margate** 1823
for *Picturesque Views of the Southern Coast of England*
Engraving, touched india proof (R.113): 158 × 239;
300 × 410; 230 × 305
Engraved inscriptions: below, with title, names of
artist and engraver and date
Inscribed by Turner: 'It requires two lines
ploughed into one about the wreck to give
distinctness to the vessel in the direction of its hull
[sketch] and side towards the bottom [sketch] and
not straight like X [referring to another cross on
two of the upper planks on right of wreck]. You
had better send me another proof because of the sky'
T05227

Turner used a variety of media with which to touch the
prints after his work (see cat.no.3). The earliest-known
touched proofs, those for the *Oxford Almanack* (see
cat.no.10), were touched with white chalk but pencil,
ink, white bodycolour and black chalk or charcoal were
also frequently used. The different methods could
indicate a variety of purposes; chalk would be adopted
for general tones, scraping-out for brilliant lights and
pencil to darken or emphasise areas (see Bell, 1903,
p.xvii).

Cooke related the story that, on receiving a proof of
'Lyme Regis' (R.94), another of the *Southern Coast* prints,
Turner 'took a piece of white chalk and a piece of black,
giving me the option as to which he should touch it with.
I chose the white; he then threw the black chalk at some
distance from him. When done, I requested he would
touch another proof in black. "No", said he "you have
had your choice and must abide by it"' (Rawlinson
1908–13, I, p.51). The purpose of the touchings was not
only to correct details but to obtain the right balance of
light and shade throughout the image, which could
either be achieved using a dark medium on the light
areas or vice versa. It would have been fascinating if the

proof touched with black that Cooke requested had been executed so that the two methods of achieving the same ends could then have been compared.

Occasionally, Turner would simply add his alterations on the proof with the chosen media but more often, as on this print, he would explain in detail the reason behind them. Here, the area on the wreck has been heavily touched in pencil and Turner has added written annotations, clearly explaining the errors made by the engraver and how the image should be altered.

These trial proofs, touched and annotated by Turner, resulted in his obtaining prints of the quality he desired, but they were also the means through which he subjected his engravers to a course of training. His teaching instructions, made up of criticism and advice, scribbled at length on the proofs which were sent to him wherever he happened to be, enabled him to enlighten the engravers as to his aims and methods. His close involvement with the engravers who worked for him has led to their becoming known as the 'Turner School'. Such instructions to his engravers forced Turner out of his customary reticence about his art (Gage, 1969, p.42) and the many touched proofs, as well as a considerable correspondence concerning the progress of the engravings, are the most thorough record of Turner's aims that we have.

imitating the appearance of pencil, were apparently executed as the basis for impressions which were later worked up in mezzotint in much the same way as outline etchings formed the first stage of the *Liber Studiorum* mezzotints. Turner, who had occasionally practised soft-ground etching in his early years, also used the technique in two of the *Liber Studiorum* plates, 'Narcissus and Echo' (R.L.90) and 'Sandbank with Gypsies' (cat.no.39). Turner may therefore have executed these preliminary soft-grounds for the two *Rivers* subjects, particularly since the completed mezzotints of these designs are by two different engravers, Thomas Lupton and John Bromley.

The other finished plates for *The Rivers of England* series also appear to have some distinct outlines, possibly etched in soft-ground. The fact that no preliminary soft-ground etchings for these plates are known is difficult to explain; it may indicate that the mezzotinters themselves were after all responsible for them, working directly over the soft-ground outlines to produce the finished mezzotints.

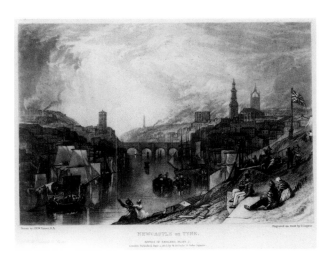

THOMAS LUPTON AFTER J.M.W. TURNER

7 **Newcastle-on-Tyne** 1823
for *The Rivers of England*
Mezzotint, Turner's Copy (R.753): 156 × 219;
345 × 510; 196 × 250
Engraved inscriptions: below, with names of artist and 'engraved on steel by T. Lupton'; centre, 'NEWCASTLE ON TYNE./RIVERS OF ENGLAND, PLATE 2./London Published June 2, 1823 by W.B. Cooke 9 Soho Square'; and *J.M.W. Turner's 15 Proofs*
T04791

The scraping of mezzotint plates was easier than the working of line engravings, and mezzotints were con-

THOMAS GOFF LUPTON (1791–1873) OR J.M.W. TURNER

6 **Newcastle-on-Tyne** 1823
for *The Rivers of England*
Soft-ground etching (R.753): 155 × 216; 302 × 432; 196 × 249
T04917

Preliminary soft-ground etchings exist for two of the *Rivers of England* mezzotints, this view of Newcastle and 'Kirkstall Abbey' (R.761). These outline designs,

sequently cheaper to produce. However, since the richness of the plates depended largely on the burr, relatively few fine impressions could be taken before deterioration of the surface began, particularly when executed on copper plates. However, the *Rivers of England* mezzotints, of which this is one, were the first to be executed on steel and although the problems with deterioration were avoided, the hard steel plates gave the engravers far less of the freedom of handling which was essential for this technique.

Turner usually claimed several early impressions of a plate as his own perquisite; his allocation of '15 Proofs' of this print has been engraved on the plate. The number of proofs Turner was allowed seems to have caused some dispute with the engravers or publishers. Turner's relationship with the Cookes finally ended after Turner claimed twenty-five proofs of each of the *Southern Coast* plates, as well as demanding to keep the trial proofs brought to him for correction, which were traditionally considered the property of the engraver (see also cat.no.43). Since so few really good impressions could be produced from copper plates or mezzotints, the engravers begrudged Turner's having too many proofs for himself. The number of proof impressions Turner was allocated by the publishers gradually increased throughout his career in proportion to his rising eminence and as a result of the introduction of steel plates; eventually he demanded at least fifty proofs (Rawlinson, 1908–13, I, p.lxvii).

In this way, Turner acquired a vast collection of proof (and other) impressions of engravings made after his work. A sizeable stock of the original copper or steel plates was also retained by him: those for subjects which had remained unfinished (see cat.no.38) or unpublished (see cat.nos.48, 50, 52–3 and 55), those which he himself had been responsible for publishing, such as many of the *Liber* plates (see under cat.nos.33–36), or those which he had bought back during his lifetime, such as those for *Picturesque Views in England and Wales*.

Turner stored this hoard of prints and plates at his London house in Queen Anne Street, where they were found on his death in 1851. Although they remained undisturbed during the long litigation over his will (see Rawlinson, 1908–13, I, p.lxvii), they were subsequently excluded from the Turner Bequest. By order of the Court of Chancery they were all dispersed, at Christie's, from 1873 to 1874, in a sequence of sales lasting twenty days, when they realized over £40,000. Some of the plates, however, such as those for *England and Wales* and for the published plates of the *Liber* were destroyed before the sale (see under cat.no.38). All the prints which passed through these sales were embossed with the blind stamp of Turner's monogram signature, IMWT, acting as a studio stamp.

THE ANTIQUARIAN BACKGROUND (cat.nos.8–11)

At the time of Turner's birth in 1775, William Woollett was regarded in the words of the painter Thomas Jones as 'the first landscape engraver in the world', a reputation based chiefly upon his fine interpretations of Wilson and Claude. His work was much admired by Turner but unfortunately, by the time Turner first became involved with producing works for engraving, there were few engravers of the same calibre as Woollett to translate Turner's early watercolours into print.

Turner's earliest connection with printmaking was apparently at the age of ten when he was employed in hand-colouring engravings made for Henry Boswell's *Picturesque Views of the Antiquities of England and Wales* (now in Chiswick Public Library). However, it was in 1793 that he received his first commission to produce drawings specifically to be engraved; these were for the *Copper-Plate Magazine*, one of many small, illustrated serials which were fashionable at the end of the eighteenth century. This was followed by several similar commissions, such as for the *Pocket Print Magazine*, which necessitated Turner making several tours in search of suitable material. Many of Turner's designs published in these topographical tour books are conventional in composition, while the somewhat mechanical techniques of the engravers of the period, who depended largely on parallel and regularly hatched strokes, failed to capture the tonal nuances that Turner was by now introducing into his watercolours.

The first engraver to do justice to Turner's work was James Basire, whose style continued the tradition of Woollett. His engravings after Turner for the *Oxford Almanacks* (see cat.no.10) and Whitaker's histories of *Whalley* (cat.no.9) and *Craven* show that he was an engraver of far greater skills than those previously involved with Turner's work. However, even Basire's engravings are rather hard and formulaic.

Not only must such renderings of his work have caused Turner some frustration but the limitations of the subject-matter must have seemed restricting to an artist of such a sophisticated imagination. Turner's work for the *Oxford Almanack*, for instance, necessitated his working within the carefully defined limits of a well-established publication; the engraved head-pieces for the *Almanack* had taken on a standardised format many years previously and artists like Michael Angelo Rooker and Edward Dayes had provided clear precedents for the kind of work required. However, Turner followed their example willingly, even though his own style had outstripped the type of work he was imitating.

In about 1809, Turner had come into contact with John Britton, an enterprising publisher who specialised in antiquarian works such as *Architectural Antiquities of Great Britain* and *The Fine Arts of the English School*. Britton encouraged an increasingly sensitive style of engraving, choosing talented artists and engravers, one of whom, John Pye, was to produce in 'Pope's Villa' (cat.no.11) the first line-engraving which managed to capture the brilliancy of tone and 'sparkle' of Turner's work. Britton succeeded in building up a school of engravers who were to transform the whole character of landscape engraving and it was from this school that Turner selected his engravers.

and those used for many of the other *Copper-Plate* views are now untraced.

This view of 'Bridgenorth' concentrating on its unusual bridge and buildings would have been a most suitable subject for this publication which specialized in picturesque architecture and scenery. According to the Rev. W. Knox Marshall who wrote the text accompanying this illustration when the *Copper-Plate Magazine* engravings were republished in 1873 as *Turner and Girtin's Picturesque Views a Hundred Years Ago*, the gate-house on the bridge was used as a prison in the eighteenth century; the prisoners would let down a basket through the floor to beg alms from the passers-by below.

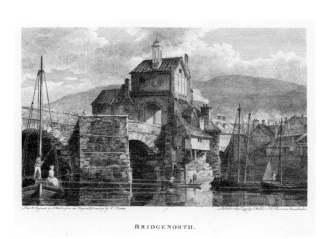

BRIDGENORTH.

JOHN WALKER (ACTIVE 1790S) AFTER
J.M.W. TURNER

8 **Bridgenorth** 1795
for *The Copper-Plate Magazine*, Vol II, Pl. 88
Engraving, first state (R.4): 111 × 170; 160 × 215;
149 × 201
Engraved inscriptions: below, with title and *Plate 88, Engraved by J. Walker from an Original Drawing by W. Turner* and *Published Aug. 1ˢᵗ 1795 by J. Walker No.16 Rosomans Row, London.*
LO1473

Turner's first commission was to produce sixteen small watercolours as illustrations for the *Copper-Plate Magazine* (reprinted in 1798 as *The Itinerant*), a topographical guide-book which contained engravings of picturesque views accompanied by a descriptive text. On receiving his commission in 1793, Turner immediately embarked on a tour of the Midlands to collect material for this work. Many sketches, including a pencil drawing for this subject, are in the *Matlock* sketchbook of 1794 (TB XIX) although the original watercolour of 'Bridgenorth'

JAMES BASIRE (1769–1822) AFTER
J.M.W. TURNER

9 **Ancient Crosses at Whalley** 1800
for Whitaker's *History of the Parish of Whalley*, Vol.1, Pl.4
Engraving, published state (R.53): 261 × 208;
309 × 242; 289 × 240 app. (trimmed at right edge)
Engraved inscriptions: above, 'PL.IV.' and 'P.31'; below, with names of artist and engraver; below border with *Reverendo admodum in Christo Patri ac Dⁿᵒ.Dⁿᵒ. . . .D.D.D T.D.Whitaker. | Published Augᵗ. 11ᵗʰ 1800 by Hatchard, Piccadilly*
LO1474

Dr Thomas Dunham Whitaker, vicar of the parish of Whalley, was a wealthy and learned antiquary and author of several studies of Yorkshire history. Turner was to produce numerous illustrations for him

in the first two decades of the nineteenth century (see cat.nos.16–18). This engraving was made for Whitaker's first commission, given *c*.1799, to illustrate his *History of the Original Parish of Whalley and Honour of Clitheroe, in the Counties of Lancaster and York*. It is interesting to note that although Turner was elected as an Associate of the Royal Academy in 1799, he was very much the junior partner in the project and was referred to by Dr. Whitaker merely as 'the draftsman' (Rawlinson, 1908–13, I, p.xxii).

The preliminary drawing for this subject (w.286) and the others for the series were, unusually, slightly enlarged when they were engraved by James Basire. The two-dimensional composition showing carved stone crosses, brasses and misericords arranged in an orderly way on the page, is conceived in a conventional antiquarian format. The composition appears somewhat alien to Turner and, combined with the rather stiff engraving, gives no indication of the brilliant plates for Whitaker's *History of Richmondshire* to come.

University Press since 1674 and were annual broadsheets showing a calendar and information with an illustrated head-piece. Although at first allegorical, the head-pieces had for many years been devoted to views of college buildings, engraved after prominent artists.

Turner was familiar with the *Almanacks* from an early age, having made copies of Rooker's 1780 *Almanack* illustration of 'Folly Bridge' in 1787 (TB I A). He was fortunate enough to receive the commission to illustrate ten views for the *Almanack* in 1799, his first important commission and a great compliment for the young artist although he was only to be paid ten guineas per plate.

All Turner's illustrations were engraved by Basire (see cat.no.9) and although an eminent engraver and one of long-standing with the *Almanack*, Turner attempted to correct his work; indeed on some proofs he gave written instructions which, however, were not necessarily followed. Turner's criticism may have been justified for Basire also came under attack from the Delegates of the Press who ordered him to 'pay greater attention to the engraving of the Oxford Almanacks and to execute it in a better manner than it has been done for some years past' (Petter, 1974, p.15). Basire was expected to engrave the text for the calendar as well as the illustration, and the Professor of Astronomy who prepared the details for the calendar complained about the amount of work incurred by the task as well as 'the still more unpleasant one of correcting the errors of a very negligent engraver' (*op.cit*, p.26).

Despite these criticisms it can be seen in this engraving that Basire has skilfully captured the reflected light on the college buildings and succeeded in producing one of the most attractive of the illustrations for the *Almanack*.

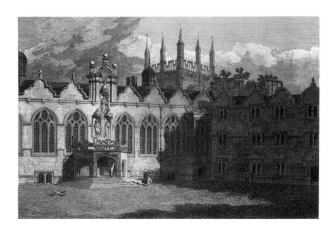

JAMES BASIRE AFTER J.M.W. TURNER

10 **View of the Chapel and Hall of Oriel College** 1801
for the *Oxford Almanack*
Engraving, published state (R.39): 320 × 452; 634 × 538; 561 × 499
Engraved inscriptions: below, with title and name of engraver and 'Drawn by Wm. Turner A.'; below title, with 'THE/ OXFORD ALMANACK/ For the Year of our Lord God / MDCCCI.'; and beneath, with table of the almanack with names omitted in section for 'OFFICERS OF THE UNIVERSITY'.
Trustees of the British Museum (1866-11-14-481)

The *Oxford Almanacks* had been published by the

11

JOHN PYE (1782–1874) AND CHARLES HEATH (1785–1848) AFTER J.M.W. TURNER

11 **Pope's Villa*** 1811
for Britton's *Fine Arts of the English School*
Engraving, later state (R.76): 174 × 229; 199 × 231 (trimmed at plate-mark)
Engraved inscriptions: below, with 'Class 1. Painting' and 'for the "Fine Arts of the English School"'; centre, 'POPE'S VILLA./ *Engraved by JOHN PYE, the Figures by CHAS HEATH, from a Picture by J.M.W. TURNER ESQR RA and P.P. in the Gallery of* / SIR JOHN FLEMING LEICESTER, BART'
LO1475

This beautiful engraving marks a turning point in the history of Turner prints. It was executed by John Pye who was the first engraver to capture the luminosity of Turner's work and Turner was delighted with the results exclaiming when he saw it, 'This will do! You can see the lights; had I known that there was a man who could do that, I would have had it done before' (Rawlinson, 1908–13, I, p.xxvi). The lightness of tone with its subtle gradations throughout, which distinguishes this plate from earlier work, is achieved by the delicacy of the engraved lines, particularly those on the sky and water; and by the continuous change in the direction of the lines as opposed to the mechanical cross-hatching used by earlier engravers.

This print was the first translation into line-engraving from an oil painting by Turner (the 'Shipwreck', cat.no.28 and several others for the *Liber Studiorum* having been engraved in mezzotint) and apart from one illustration by Gainsborough, was the only landscape to appear in Britton's *Fine Arts*.

The accompanying text was written by the publisher John Britton after discussing its contents with Turner. It appears from a letter from Turner to Britton (Gage, 1980, no.43) that they had originally proposed to propound the beauties of 'Elevated Landscape against the aspersions of Map making criticism' (referring to the painter, Henry Fuseli's derogatory criticism of topographical landscape as 'map-work'). However, much to Turner's regret, this had been omitted in the printed text. Britton, nevertheless, praises 'Pope's Villa' highly and lays particular emphasis on the luminosity of the painting, describing its 'pastoral simplicity, rendered sweeter by the serenity of evening'.

COOKE'S 'SOUTHERN COAST' AND 'VIEWS IN SUSSEX'
(cat.nos.12–14)

Picturesque Views of the Southern Coast of England was devised by W.B. Cooke, an able engraver as well as a printseller and publisher, and was intended to be the first part of a much larger scheme depicting the entire coast of England. Eighty views were engraved and were issued in sixteen parts, each with three plates and two vignettes, which were published between 1814 and 1826. Turner was originally contracted for twenty-four drawings at £7. 10s. each, a fee which increased to ten guineas after the first four issues. Since Cooke received twenty-five guineas and later £40 for each plate, Turner was obviously still the lesser partner in the project and may have undertaken the work mainly in the hope of enhancing his career. Various prominent artists including Peter de Wint, Henry Edridge and Joshua Cristall also made designs for the series, although Turner's illustrations were soon perceived to be superior and he was asked to produce a further sixteen illustrations, thereby becoming responsible for a large proportion of the work.

Although Cooke and his brother George had initially planned to engrave all the views for the project themselves, they had difficulties in finishing the plates in the time envisaged and the parts appeared sporadically. To speed up the publication, they employed other engravers such as William Miller and Edward Goodall, thereby introducing these young engravers to a life-long involvement with Turner which proved mutually beneficial to both artist and engraver.

The completed series was bound into two volumes with the views arranged geographically from Kent to Somerset. Towards the end of the project, however, Turner quarrelled with the Cookes over payment and the number of proof impressions he demanded (see cat.no.7) and Turner threatened to bring out the projected sequel, the *Northern Coast*, himself; all contact between them ceased in 1827 (see cat.no.43).

Before this time, however, Turner had collaborated with the Cookes on various other projects including the series of *Views in Sussex* for the Sussex M.P. John Fuller (R.128–36). Eight views plus an emblematic frontispiece were engraved between 1816 and 1820 although two of these (R.135–6) remained as outline etchings only. A further four of the Sussex watercolours were engraved in aquatint for printing or tinting in colours (R.822–5), a technique rarely used in prints after Turner. The *Views in Sussex* remained unfinished and many of the other series which the Cookes embarked

upon, such as *The Rivers of Devon* (R.137–40) and *Marine Views* (R.770–2), suffered the same fate or proved to be financial failures; the lack of success of these projects was perhaps due to the Cookes' over-ambitious attempt to act both as engravers and publishers.

The series of watercolours Turner executed for the *Southern Coast* was the first to be specifically produced for publication in serial form. This project, along with others such as *Views in Sussex*, represents the type of engraving commission which was to engage Turner's attention in the future.

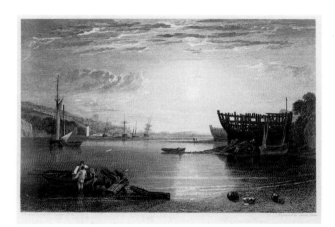

GEORGE COOKE AFTER J.M.W. TURNER

12 **Teignmouth** 1815
for *Picturesque Views of the Southern Coast of England*
Engraving, touched india proof (R.95): 153 × 226;
291 × 438; 228 × 301
Engraved inscriptions: below, with title, names of artist and engraver.
Inscribed by Turner: 'The tone of the church requires a little more solidity about the upper part but take care of blackness. One of the figures standing on the shore in the middle distance is too much a Falstaff, the other Master Slender. Make the sun, if you can more visible as to *disk* [sketch] at the uppermost side, and then the plate will *do*. The boat's foremast has no bottom to it, burnish one in and make a shadow. Rather too positive'
T05382

George Cooke had been apprenticed to Basire (see cat.nos.9 and 10) and had been enthusiastic about Turner's *Almanack* drawings. He executed twenty engravings after Turner up to *c*.1826, and it can be seen that between this early engraving and later ones such as 'Brighton' (cat.no.13) he greatly improved his skills under Turner's guidance. This is one of several proofs whose annotations are typical of the detailed and

exacting criticism Turner gave to the *Southern Coast* engravers (see cat.no.5). It is one of a large number of trial proofs which are included in the collection which once belonged to Lord Tweedmouth, recently purchased by the Tate Gallery.

Turner made tours of the West Country in 1811, 1813, and possibly 1814, shortly after receiving the commission for the *Southern Coast*. He made studies of 'Teignmouth' in the *Corfe to Dartmouth* sketchbook (TB CXXIV 36,37) on the earlier tour and must have been pleased with the composition for he painted an oil of this subject in 1812 (B&J 120), as well as the watercolour (W.452) on which this engraving was based in the following year.

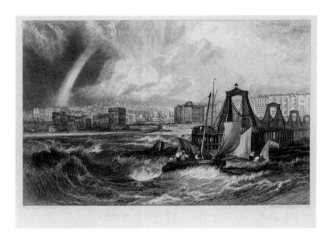

GEORGE COOKE AFTER J.M.W. TURNER

13 **Brighton** 1825
for *Picturesque Views of the Southern Coast of England*
Engraving, india proof (R.122): 154 × 231;
355 × 493; 242 × 312
Engraved inscriptions: below, with title, names of artist and engraver and date
T04421

The *Southern Coast* plates, executed the same size as the drawings, are worked with a combination of etching and engraving. The foreground lines are often etched in over the burin-work and the blackness and strength of these lines, contrasted with the light and delicate ones used in the distance, enhances the effects of recession, giving accent and chiaroscuro unobtainable by line-engraving alone.

This view of Brighton from the sea, showing a panorama of the coast-line with its wealth of detail and a foreshortened view of the recently erected Chain Pier, is typical of the complex compositional formats of many of the *Southern Coast* subjects; the images manage to express an extraordinary amount although compressed

within a tiny area. Although most of the subjects display the same combination of sea, earth, atmospheric effects and local figures, each is an individual and naturalistic portrait of the place.

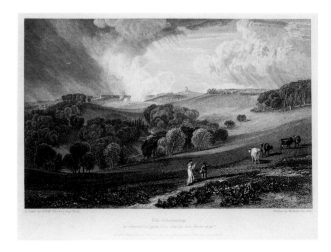

W.B. COOKE AFTER J.M.W. TURNER

14 **Brightling Observatory, from Rosehill Park** 1816
for *Views in Sussex*
Engraving, first published state on india paper
(R.130): 190 × 281; 335 × 443; 253 × 330
Engraved inscriptions: below, with names of artist and engraver, and *The Observatory/at Rosehill, Sussex, The Seat of John Fuller Esq.^re/London published as the Act directs by W.B. Cooke, York Place, Pentonville./SEP 1. 1816*
T04432

Turner was first commissioned to do work for John (or 'Jack') Fuller in about 1810, when he painted an oil of Fuller's country estate at Rosehill (B&J 211). It was not until about 1815 that he started work on the water-colours for *Views in Sussex*, which depict the countryside in the vicinity of Rosehill.

Rosehill Park (now renamed Brightling Park) was built by Fuller's great uncle, Thomas Fuller, from the profits of the sugar trade in Jamaica. This view shows the 646-foot high domed observatory designed by the architect Sir Robert Smirke, one of a number of embellishments which Jack Fuller himself was responsible for adding to the grounds and which remains at Brightling Park to this day. Cooke has rendered with great skill the blustery clouds and billowing smoke which frame the Observatory in the distance, and which impress the viewer with the effect of a breezy summer's day.

WHITAKER'S 'HISTORY OF RICHMONDSHIRE' (cat.nos.15–18)

In 1816 Turner was commissioned by Longmans to provide the landscape illustrations for a seven-volume history of the county of Yorkshire which was to be written by Dr Whitaker (see under cat.no.9). The book was intended to be Whitaker's *magnum opus* and was planned on a far more lavish scale than any of his previous publications on which Turner had already collaborated – the *History of Whalley* (see cat.no.9), the *History of Craven* and *Loidis and Elmete* (a history of the county of Leeds). Turner was asked to provide 120 subjects, for which he was to receive twenty-five guineas each; despite apparently being beaten down by the publishers from forty guineas to this lower sum, this was the artist's most valuable commission to date.

However, the publication was abandoned shortly after the first part, *The History of Richmondshire*, had appeared, issued at intervals between 1819 and 1823 and containing twenty engravings after Turner. The publishers overextended themselves (the final cost of this first part alone amounted to nearly £10,000), as became clear at an early stage in the project when they tried to sell the watercolours by Turner in an attempt to recoup some of their investment. At the outset the project seems to have attracted a healthy number of subscribers – Rawlinson points out (1908–13, I, p.89) that the large paper copies, numbering 160, were fully subscribed to, and the small paper edition, with 550 copies, well over half. But subscribers seem to have lost interest soon afterwards and Longmans were forced to cut the numbers of copies they printed (see Hill, 1984, p.26). Another contributory factor to the failure of the project was Whitaker's untimely death in December 1821. The series, however, became greatly sought after by the public, and went through many reprints (see Rawlinson, *op.cit.*, p.91 and also under cat.no.17). It remains today one of the most popular of Turner's engraved landscape series.

15 **St. Agatha's Abbey, Easby: colour study*** *c.*1818
Watercolour
393 × 503
Turner Bequest; CCLXIII 360
D25483

This is a colour study for the finished watercolour of St. Agatha's Abbey in the British Museum (W.561), from which the engraving by Le Keux for Whitaker's *History of Richmondshire* was made (cat.no.16). The sheet is

divided into broad areas of primary colour – red, yellow and blue, demonstrating Turner's concern to establish the chief tonal areas of the design through colour alone. These tonal values were adopted in the finished watercolour, and subsequently translated in the engraving together with the pattern of light and shade (cat.no.16).

Although colour beginnings had been a feature of Turner's working practice since the 1790s, it was with the *Richmondshire* series that he first began to produce them in sequences. Other colour studies survive for this series in the Turner Bequest, together with many more for *Picturesque Views in England and Wales*.

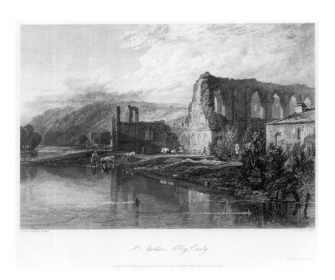

J. LE KEUX (1783–1846) AFTER J.M.W TURNER

16 **St. Agatha's Abbey, Easby*** 1822
for *The History of Richmondshire*
Engraving, first published state on india paper (R.171): 214 × 283; 323 × 483; trimmed within

plate-mark along vertical edges
Engraved inscriptions: below, with title, names of artist and engraver; bottom, *Published Feb.ʸ 14.ᵗʰ 1822, by Longman, & Co. Paternoster Row, and Hurst Robinson, & Co. Cheapside, London*; and lower right, *Printed by McQueen & Co.*
T04443

Most of the finished watercolours for Whitaker's *History of Richmondshire* were based on drawings made by Turner on a special tour to Yorkshire in 1816. Although the artist visited St. Agatha's on his tour that summer – and made a few slight sketches of the Abbey in the *Yorkshire 2* sketchbook (TB CXLV 122, 3) – this composition was based much more closely on a detailed pencil study made some years earlier in the *North of England* sketchbook, 1797 (TB XXIV 25). Indeed, Turner made two other finished versions in watercolour of St. Agatha's Abbey in the 1790s which were engraved for Dr Broadley's *Poems* over forty years later (R.640 and 642).

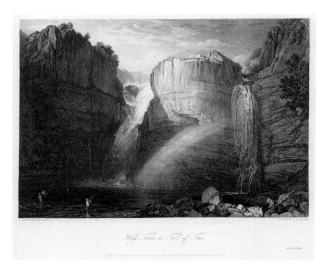

JOHN LANDSEER (1769–1852) AFTER J.M.W. TURNER

17 **High Force or Fall of Tees** 1821
for *The History of Richmondshire*
Engraving, first published state on india paper (R.173, but where publication date is given as 1822): 193 × 272; 318 × 483; 294 × 441
Engraved inscriptions: below, with title, names of artist and engraver; bottom, *Published by Longman & Co. Paternoster Row, and Hurst Robinson, & Co. Cheapside, London Sept.ʳ 12.ᵗʰ 1821*; lower right, 'Printed by H. Triggs'
T04447

Situated about six miles above Middleton in Teesdale, High Force was described by Whitaker in the accompanying text to *The History of Richmondshire* as 'one of the finest cataracts in the island, whose roar is audible long before it is perceptible to the eye'. According to Mrs Alfred Hunt, who wrote the commentary to a reprinted edition of the *Richmondshire* plates in 1891: 'Turner is said to have been so delighted with "High Force", that on one occasion he all but lost his life there. He stayed so long sketching one evening that he was overtaken by darkness, and . . . was quite unable to see his way.' In Turner's day the water usually flowed in two channels; the exceptionally large quantities of water depicted in Landseer's engraving testify to the wet summer of 1816 when Turner toured Yorkshire in search of material for the *Richmondshire* project.

John Landseer engraved a number of plates after Turner in the 1790s for a projected series of views in the Isle of Wight (R.34–37a) as well as one of the subjects for Hakewill's *Picturesque Tour in Italy* (R.145). In the early years of the nineteenth century he led a campaign to win full recognition for engravers at the Royal Academy, in which he had the support of other fellow engravers including John Pye (see cat.nos.11 and 18; and also Gage, 1988, pp.10 ff and Dyson, 1984, pp.57–8).

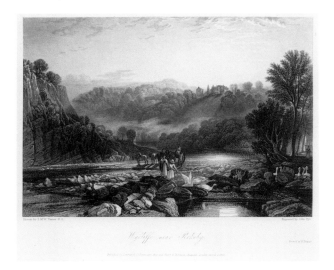

18 **Wycliffe, Near Rokeby** 1823
for *The History of Richmondshire*
Engraving, first published state on india paper
(R.177): 191 × 270; 316 × 483; 280 × 429
Engraved inscriptions: below, with title, names of artist and engraver; bottom, *Published by Longman & Cº. Paternoster Row and Hurst & Robinson, Cheapside, London, March 1. 1823*; lower right, 'Printed by H. Triggs'
T04456

Wycliffe Hall is situated two miles downstream from the confluence of the rivers Greta and Tees at Rokeby, a subject also engraved by John Pye for *The History of Richmondshire* (R.175). All of Turner's illustrations for the series were apparently selected in advance by a committee of four local gentlemen, but this seems to have neither restricted his creative imagination nor to have prevented his adding his own personal touches. An interesting anecdote relating to the engraving of this plate by John Pye is recorded by Rawlinson (1908–13, I, p.98). Pye stated that Turner, when touching the proof, introduced a burst of light (the rays above the Hall, just visible in this impression) which was not in the preliminary drawing. On being asked his reason Turner replied that 'this is the place where Wickliffe [*sic*; John Wycliffe, 1324–84, translator of the Bible into English] was born and the light of the glorious Reformation'. The artist then added that the geese in the picture represented the 'old superstitions' which the young girls – 'the genius of the Reformation' – were driving away.

A rare proof impression of this plate exists in the British Museum (1891-6-17-39), bearing a long engraved inscription which tells of Wycliffe's achievements as a Protestant reformer, and thus giving credence to this allegorical reading of the subject. Wilton (1987, p.120) suggests that Turner may have reserved such impressions for circulation amongst the radical friends of his Yorkshire patron, Walter Fawkes. However the impression in the British Museum clearly remained the perquisite of the engraver, for it is inscribed with the dedication 'To Doctor Percy from his friend John Pye'. Doctor Percy amassed a fine collection of *Liber Studiorum* prints which were purchased from him in 1865 by the Victoria and Albert Museum (see Pye & Roget, 1879, p.98).

'PICTURESQUE VIEWS IN ENGLAND AND WALES'
(cat.nos.19–23)

The most ambitious of the engraving projects in which Turner became involved in the 1820s and 1830s was Charles Heath's *Picturesque Views in England and Wales*. By profession an engraver rather than a publisher, Heath had in 1809 engraved the figures in Pye's sensitive translation after Turner's oil painting of the destruction of Pope's villa at Twickenham (see cat.no.11) – the occasion of his first acquaintance with the artist. From the 1820s, however, Heath began to devote most of his energy to publishing: besides the *England and Wales* series, he embarked on various other projects around this time, such as the popular illustrated annuals and the 'Rivers of France', for which Turner was also engaged to make designs (see cat.nos.57–60 and 24–7).

In a recently-discovered letter to the banker Dawson Turner dated February 1825, Heath writes: 'I have just begun a most splendid work from Turner the Academician. He is making me 120 Drawings of England and Wales – I have just got four and they are the finest things I ever saw they cost me 30 Gins [guineas] each ... any one who has seen them says it will be the best and most lucrative speculation ever executed of that description. I mean to have them engraved by all the first Artists. Messrs Hurst & Robinson are to have half the work on condition they find all the capital necessary...' (quoted Shanes, 1984, p.52).

As Heath indicated in his letter, the watercolours for the series were amongst the finest Turner had ever made, and the engravers recruited to translate them included some of the most talented of those who had worked with the artist over the previous fifteen years, such as Goodall (see cat.no.20), Wallis (cat.no.22), and Willmore (cat.no.23). Despite this, however, the series was to prove a commercial failure and was soon beset with problems. In January 1826, the co-publishers who had originally put up the capital, Hurst and Robinson, went bankrupt. During the next twelve years, the project was underwritten by a series of eminent publishers who in turn took it up and abandoned it when faced with financial losses. Robert Jennings, who had taken over responsibility for the venture after Hurst and Robinson's bankruptcy, sold out to Moon, Boys and Graves in 1831 and they, in turn, sold out to Longmans in 1835. It was Longmans who decided to terminate publication in 1838 after only ninety-six plates had appeared, published in parts of four prints each (together with descriptive text) over the previous eleven years; and these they now bound up for sale into two volumes of forty-eight plates each. Heath, in the meantime, had become insolvent.

In 1839, in an attempt to recoup some of their losses, Longmans decided to sell the entire stock of prints and plates from the series, which were accordingly put up for auction at Messrs Southgate & Company in Fleet Street. Just before the sale started, Turner himself managed to purchase the stock privately at the reserve price of £3,000, much to the consternation of all the prospective purchasers. One of these was H.G. Bohn, a dealer in cheap reprints who had had his eye on the ninety-six copper plates, and to whom Turner triumphantly announced: 'So, sir, you were going to buy my England and Wales, to sell cheap, I suppose – make umbrella prints of them, eh? – but I have taken care of that. No more of my plates shall be worn to shadows' (Alaric Watts; quoted Finberg, 1961, p.374).

One of the reasons widely quoted for the commercial failure of the *England and Wales* project is the fact that Turner apparently insisted that copper be used in preference to the more hard-wearing and economical steel. Whether steel was in fact considered a realistic option by Heath as early as 1824 when the series was first conceived is not known – certainly very little had yet been published in line on steel by that date except for images on a much smaller scale. Nevertheless the series does seem to have suffered serious competition from a variety of similar, cheaper publications flooding the market over the same period, reproducing the work of such popular artists as Samuel Prout, Clarkson Stanfield and David Roberts (see Finberg, 1961, p.375). Repeated attempts were made by the publishers to promote the *England and Wales* series by holding exhibitions of the watercolours – in 1829 at the Egyptian Hall, in 1831 at the Freemasons Tavern and in 1833 at the Gallery of Moon, Boys and Graves in Pall Mall. But the public simply could not be tempted to subscribe.

Nevertheless *Picturesque Views in England and Wales* is today regarded as one of the finest and certainly one of the most important of all the engraved series after Turner's work. Whether one is presented with fishermen setting sail in the early morning (cat.no.19), or elegant figures strolling along Richmond Terrace in the early evening (cat.no.23); children at play by day (cat.no.21), or workmen at their chores by night (cat.no.22), it is the relationship of man to the landscape which is now the artist's central concern. In the variety and richness of its subject-matter, and in the breadth and universality of its vision, *England and Wales* surpasses all the other series in which Turner had so far been involved; and the engravings are some of the most sophisticated and accomplished ever made after his work.

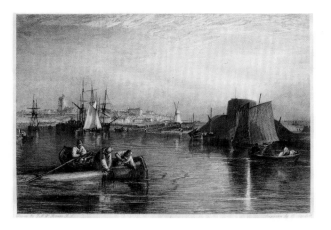

19 **Aldborough** *c.*1826
Watercolour with some scraping-out
279 × 400
N05236

With its assured composition, full rich colour and high
degree of finish, 'Aldborough' is typical of the prelimi-
nary drawings Turner contributed to Heath's *Pictur-
esque Views in England and Wales* and is also characteristic
of the elaborate watercolours he was producing for the
engraver during his mature period. It has been de-
scribed as one of the most serene subjects he made for
the series, with its emphasis on a group of fishermen
about to set sail for the day's catch, and the early
morning sun casting a rich glow across the still,
translucent water in the foreground. Like the other
watercolours in the series, it was reduced in size by
approximately one half when it was engraved
(cat.no.20).

As was the case for the *Southern Coast* and *The History of
Richmondshire* series (cat.nos.1–5, 12–13 and 15–18), the
original watercolours for *England and Wales* were sold by
Turner to the publishers, and are now dispersed in
collections throughout the world. Of the ninety-six
watercolours which were engraved for the series, this is
the only one in the collection of the Tate Gallery, being
bequeathed in 1940 by Beresford Rimington Heaton.

EDWARD GOODALL (1795–1870) AFTER
J.M.W. TURNER
20 **Alborough** [Aldborough], **Suffolk** 1827
for *Picturesque Views in England and Wales*
Engraving, first published state on india paper
(R.219): 163 × 233; 433 × 602; 252 × 305
Engraved inscriptions: below, with names of artist
and engraver
T04522

Many of the engravers who contributed to the *England
and Wales* series had previous experience of working
with Turner. Edward Goodall, the engraver of this
plate, had first collaborated with Turner some years
earlier over three plates for the *Southern Coast*. In 1827
alone, the year in which 'Aldborough' was published,
four other plates by Goodall after Turner were issued;
two of them were also for *England and Wales* ('Rievaulx
Abbey', R.209, and 'Fall of the Tees', R.214), and one
was the impressive single plate, 'Tivoli' (cat.no.86).
Goodall was one of the ablest and most sensitive of the
interpreters of Turner's work. It is through his son's
Reminiscences, published in 1902, that so much of our
important information concerning Turner's relation-
ship with his engravers is gleaned.

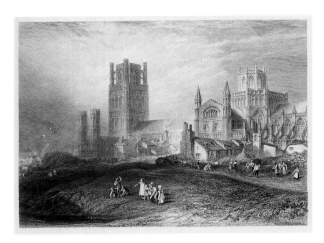

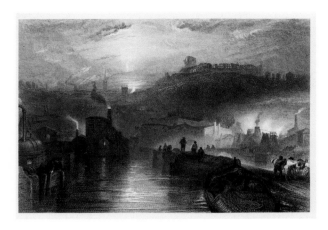

Thomas Higham (1795–1844) after J.M.W. Turner

21 Ely Cathedral, Cambridgeshire 1833
for *Picturesque Views in England and Wales*
Engraving, first published state on india paper
(R.269): 169 × 229; 434 × 597; 249 × 304
T05092

The subjects selected by Turner for *England and Wales* fall into a wide range of categories covering almost every aspect of his range as a landscape painter – coastal subjects (cat.no.20), urban views (cat.no.22), English pastoral scenes (cat.no.23) or, as with this example, views of English cathedrals and abbeys. Yet unlike the previous series of views he was commissioned to make for the engraver (cat.nos.1–5 and 12–18), those for *England and Wales* are not related in any way to a clear theme. Rather, they represent Turner's own choice of views, often selected from sketches made many years before on tours of England he had embarked on since the beginning of his career. 'Ely', for example, is closely based on a detailed pencil study made on his tour to the Midlands in 1794 (private collection, repr. Shanes 1980, p.39). This had been an exercise in architectural topography alone and it is in character with Turner's mature approach to *England and Wales* that in the version now made for engraving he should have enlivened the foreground with various figures absorbed in their respective pastimes: a group of young boys appear to be throwing stones into a pond, observed by a group of onlookers.

R. Wallis (1794–1878) after J.M.W. Turner

22 Dudley, Worcestershire 1835
for *Picturesque Views in England and Wales*
Engraving, first published state on india paper
(R.282): 163 × 239; 440 × 609; 252 × 303
T05097

Although many of the subjects made by Turner for *England and Wales* were adapted from extant sketches or watercolours (see under cat.no.21), thirteen were based on new material gathered by him on a tour to the Midlands in 1830 undertaken especially for this project. 'Dudley', for example, is based on studies in the *Kenilworth* (TB CCXXXVIII) and *Birmingham and Coventry* (TB CCXL) sketchbooks used on that tour. It is, however, the only subject in the series to feature industry in a central role. In the later part of the nineteenth century the watercolour (W.858; The Lady Lever Art Gallery, Liverpool) was owned by Ruskin who wrote that it represented 'one of Turner's first expressions of his full understanding of what England was to become', and drew attention to the ruined castle and church spires as 'emblems of the passing away of the baron and the monk'.

The watercolour was one of sixty-six from the series which were shown at the special exhibition held by the publishers, Moon, Boys and Graves, at their Gallery in Pall Mall in 1833 to promote the sale of the engravings by subscription. Most of the watercolours had been sold by Heath after they were engraved, and were lent to the exhibition by the private collectors who had purchased them; that for 'Ely', for example, cat.no.21, was lent by Thomas Griffith, who was later to become Turner's agent. 'Dudley', however, was listed in the catalogue as being in Heath's possession so clearly had not yet been engraved by that date (see Shanes, 1980, p.157).

Robert Wallis had first collaborated with Turner when he engraved a plate for Cooke's *Southern Coast*. In addition to 'Dudley', he worked on eleven other sub-

jects for *England and Wales*, and continued to engrave work for Turner until the artist's death, including some of the late single plates.

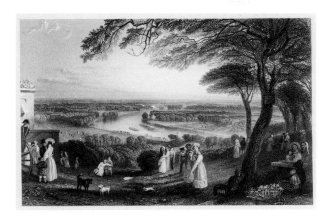

JAMES TIBBITTS WILLMORE (1800–63)
AFTER J.M.W. TURNER

23 **Richmond Terrace, Surrey** 1838
for *Picturesque Views in England and Wales*
Engraving, first published state on india paper
(R.303): 165 × 249; 434 × 598; 243 × 317
T04611

The famous panorama from Richmond Hill was a subject often treated by Turner, his most elaborate statement being the large canvas of 1819, 'England: Richmond Hill on the Prince Regent's Birthday' (B&J 140; Gallery 108). In this view of 'Richmond Terrace' the artist's viewpoint was close to the corner of Wick House built for Sir Joshua Reynolds by Sir William Chambers (still standing today). Another view of Richmond was made by Turner for *England and Wales* looking towards the bridge in the centre and with Richmond Hill in the far left-hand distance (w.833). A feature common to all these views is the inclusion of elegant figures, among the most vivacious and graceful he ever drew, whose presence proclaims Richmond's charms as a place of resort.

Richmond Terrace was one of the last plates to be engraved for *England and Wales* in 1838 when the project was prematurely brought to a close by Heath's insolvency. Willmore engraved thirteen other subjects for the series and, like Wallis (see cat.no.22), also worked on some of the large single plates towards the end of Turner's life.

THE 'RIVERS OF FRANCE'
(cat.nos.24–27)

Between 1833 and 1835, when continental topography was enjoying a great vogue in England, three handsome volumes containing steel engraved illustrations of French river scenery by Turner appeared on the market. The publisher, Charles Heath, had already engaged Turner's services, both for the series *Picturesque Views in England and Wales* (see cat.nos.19–23) and for some of his popular illustrated annuals such as *The Keepsake* (cat.nos.59–60). Of the three volumes of French river scenery, the first to appear, in 1833, was *Wanderings by the Loire . . . with twenty-one engravings from Drawings by J.M.W. Turner, Esq. R.A.*; the second and third volumes, *Wanderings by the Seine*, each containing twenty plates, followed in 1834 and 1835 (see cat.no.27). All three were accompanied by a descriptive text written by Leitch Ritchie, a journalist whom Heath had employed for his *Picturesque Annual* and other publications.

The finished designs by Turner for this project are all executed in bodycolour on small sheets of blue paper. Most of those for the Loire were once owned by Ruskin, and are now in the Ashmolean Museum in Oxford (w.930–50; see also Luke Herrmann, *Ruskin and Turner*, 1968, pp.71–80); whilst nearly all those for the Seine remained in Turner's possession and are now in the Bequest (w.951–90). The Loire and Seine volumes were originally intended to form part of a much larger work on the 'Great Rivers of Europe', or 'River Scenery of Europe', and there are many similar studies by Turner of other European rivers such as the Meuse and the Moselle in the Bequest, but which, however, were never engraved.

Although in this period Turner was already using bodycolour on mid-toned paper for informal colour sketches – for example at Petworth and in Venice – those for the French river scenery were the only finished designs in such a combination that he made for the engraver. It has been pointed out that the use of bodycolour on blue paper helped to clarify the 'progression along the tonal scale from dark to light', the paper providing a mid tone above or below which light or dark accents could be placed (Alfrey, see *Turner en France*, 1982, p.189). Colour played a crucial role in this context, helping define spatial recession; and in its sheer intensity also seems to have been deliberately intended by Turner to force his engravers genuinely to 'translate' his work into the wholly different medium of black and white (see Wilton, 1979, pp.168–9). The French rivers drawings are at the same time amongst the least 'linear'

of the designs ever supplied by Turner for his engravers, and cannot have been easy to interpret. Details which are hardly legible in the original designs do, nevertheless, appear in the final engravings (see under cat.nos.25–6), prompting one to conclude either that Turner must have collaborated closely with the engravers at proof stage, or that they had become remarkably skilled in translating his drawings (see also under cat.nos.63 and 67).

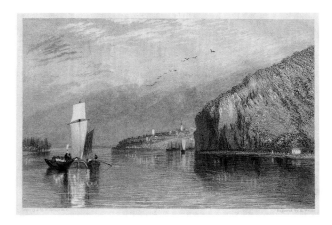

R. WALLIS AFTER J.M.W. TURNER

24 **Coteaux de Mauves** 1833
for *Turner's Annual Tour – The Loire*
Engraving, first published state on india paper
(R.451): 98 × 144; 295 × 436; 143 × 218
Engraved inscriptions: below, with names of artist
and engraver, and in lower right-hand corner,
'Printed by Mᶜ Queen'
T04696

Turner only made one tour to the Loire in 1826, travelling up river from Nantes to Orleans in the opposite direction from which the reader traces his journey in *Wanderings by the Loire* (it is possible that the tour was undertaken before Turner had received the commission for the French Rivers project). The fact that he only made a single journey along the Loire, by comparison with the numerous times he visited the Seine, has been seen to account for the difference between the drawings and engravings of each series: 'Those for the Loire tend to be simple in character, while those for the Seine are dense, complex and allusive' (Alfrey, 1982, p.198). This subject resembles many of the other views in the Loire series in which the dominant motif is the steep bluff or cliff overlooking the river in the middle distance, the chief focus of interest

being provided by assorted river craft in the foreground.

The Ashmolean watercolour (w.949) for this engraving is based on a pencil sketch in the *Nantes, Angers and Saumur* sketchbook (TB CCXLVIII 9v). Like others in the series, the watercolour relies for its effect on subtle colouring and delicate atmosphere, qualities which Ruskin regarded as almost impossible to translate into engraved form. Speaking of another of the drawings in the series, the 'Scene on the Loire' (w.947) which was his favourite, he wrote: 'The engravers could not attempt [it], because it was too lovely; or would not attempt, because there was, to their notion, nothing in it' (quoted Alfrey, *ibid*). For this reason the Loire views have often been regarded as less successful than those for the Seine as an engraved sequence.

Turner added a small white cottage to Wallis's third engraver's proof of the 'Coteaux de Mauves' (British Museum); this, together with more clouds in the sky, appeared in the published state of the print.

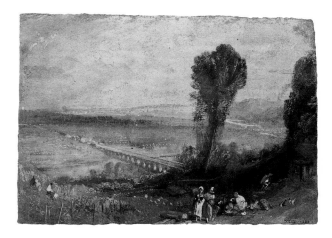

25 **Bridges at St. Cloud and Sèvres*** *c*.1832
Bodycolour with some pen on blue paper
140 × 193
Turner Bequest; CCLIX 123
D24688

If when working up his finished designs for the Loire series Turner had to rely on material gathered on a single tour in 1826 (see under cat.no.24), for those of the Seine, by contrast, he was able to draw inspiration from three tours made over the course of a decade – 1821, 1829 and 1832. For this reason the Seine views tend to be more varied, packed with greater incident and detail of local life; in the foreground of this drawing, for example, a group of peasants are busily gathering in the grape harvest. And if for the Loire views, the onlooker was usually placed somewhere mid-stream or close to

the water's edge, in the Seine series Turner loved nothing better than to position the viewer on high ground, looking down onto the wide sweep of the river below. In this panoramic view the course of the river, indicated in white bodycolour, is not always clear, particularly the section between the bridges of St. Cloud and Sèvres; it is, however, rendered more crisply in the engraving.

houses and trees which line the approach road to the bridge of St. Cloud in the middle distance.

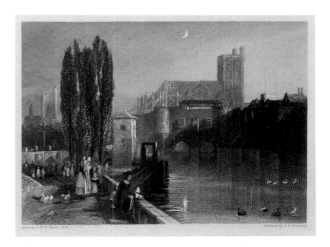

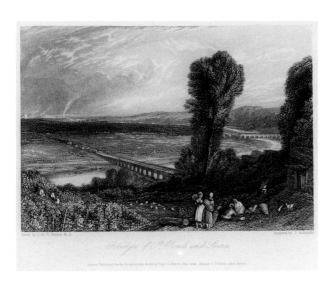

J. [?W.] RADCLYFFE (?1783–?1855) AFTER J.M.W. TURNER

26 **Bridges of St. Cloud and Sèvres*** 1835
for *Turner's Annual Tour – The Seine*
Engraving, second published state on india paper (R.482): 100 × 137; 298 × 433; 152 × 229
Engraved inscriptions: below, with title, names of artist and engraver and, bottom, 'London. Published for the proprietor, by Hodgson, Boys & Graves, Pall Mall, Rittner & Cº Paris, Asher, Berlin'
Lib. 4242

This view is adapted from a number of pencil sketches by Turner in the *Paris and Environs* sketchbook (TB CCLVII 147, 147a) and the *Seine and Paris* sketchbook (TB CCLIV 12, 12a, 14, 15a, 16). As Alfrey has pointed out (*op.cit.*, p.446), the pencil sketches tend to magnify the horizon so as to emphasise that the skyline of Paris is visible in the distance, a detail evident in the engraving but not, surprisingly, in the preparatory watercolour (cat.no.25); perhaps Turner supplied Radclyffe with such extra information at proof stage. In the engraving other details appear which are almost impossible to make out in the preliminary watercolour, such as the

27 **Turner's Annual Tour – Wanderings by The Seine, from Rouen to the Source**
By Leitch Ritchie, Esq . . . with Twenty Engravings from Drawings by J.M.W. Turner, Esq. R.A.
London, 1835
Open at pp.244–5: 'Troyes'
Engraving by J.C. Armytage (1802–97) after Turner, fifth state (R.492): 102 × 138; 127 × 206 (trimmed within plate-mark)
Engraved inscriptions: below, with title, names of artist and engraver and, bottom, 'London. Published for the Proprietor by Longman & Cº. Paternoster Row – Rittner & Cº. Paris, Asher, Berlin'
Lib. 1043

This is the last illustration by Turner which appears in *Wanderings by the Seine*, and was based on a number of studies he made on his 1832 French tour in the *Paris and Environs* sketchbook (TB CCLVII 101a, 103a and 108a). Leitch Ritchie described Troyes as 'a mean and miserable town, without even that character of the picturesque which almost always belongs to antiquity'. Perhaps, as has been pointed out elsewhere (Alfrey, *op.cit.*, p.464), Turner's real motive in making the journey was to visit nearby Brienne, in connection with his commission from Cadell to illustrate Scott's *Life of Napoleon* (see under cat.no.75).

Ritchie regarded the cathedral as 'most worthy of notice', being of 'vast extent' and having 'much grandeur in the general proportions'. Although Turner's

illustrations do not generally bear a close correlation to Ritchie's text, the artist has similarly chosen to emphasise the importance of the cathedral. The original watercolour in the Turner Bequest (TB CCLIX 126) is rendered in an attractive combination of mellow colours such as pinks and purples, and suffused with the glow of a soft, evening light. In translating the design, the engraver – without recourse to colour – has chosen to emphasise the long shadows cast by the figures to the left, and has added a crescent moon above the cathedral to indicate that the scene is set at evening.

Although this last volume of *Turner's Annual Tour* bears the date 1835, it was actually published in December, 1834, in order to capture the Christmas market (Alfrey, *op.cit.*, p.192), which is indicative of its popular appeal.

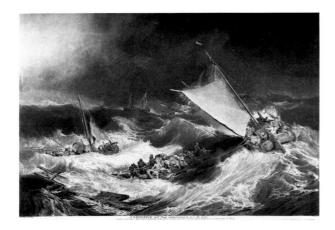

C. TURNER (1773–1857) AFTER J.M.W. TURNER

28 **A Shipwreck*** 1807
Mezzotint printed in colours, second state (R.751): 570 × 809; 618 × 849; 585 × 814
Engraved inscriptions: with names of artist and engraver; below, *London Published Jan.ʸ 1. 1807. by C. Turner, No. 50 Warren Street, Fitzroy Square*, and with title *A SHIPWRECK with Boats endeavouring to save the Crew. | This Print is with permission engraved from the original Picture in the possession of Sir John Leicester Barᵗ. to whom it his* [sic] *humbly Dedicated by his most obᵗ. & very hᵇˡᵉ Servᵗ. C. Turner*
Trustees of the British Museum, 1940-6-1-14

When Turner exhibited his oil of 'The Shipwreck' (B&J 54; Gallery 107) at his own gallery in Queen Anne Street in the spring of 1805, it was so well received that the engraver Charles Turner – no relation of the artist, but an old colleague from the Academy Schools – offered to publish a large mezzotint of the painting at his

own expense. A prospectus was issued by Turner soon afterwards, giving details of the subscription proposals: standard impressions of the print would cost two guineas, proofs four; the print would be published by the end of the year (see Finberg, 1961, pp.118–9). The picture having been reserved for purchase at the exhibition by Sir John Fleming Leicester – one of the most important of Turner's early patrons – Turner wrote to him requesting permission to retain it (he literally asks for its 'detention') while it was being engraved – a period he anticipated as lasting no longer than 'beyond the time of your return to town for the winter' (Gage, 1980, no.9). Strictly speaking 'The Shipwreck' in the meantime seems to have remained the artist's property: Turner drew up a contract with Charles Turner in which he agreed to loan him the picture for a fee of twenty-five guineas (Gage, *op.cit.*, no.10); payment by Leicester was deferred until 31 January 1806 (Butlin & Joll, 1984, p.43), and the painting was evidently delivered to him some time that year (see Whittingham, 1986, pp.25 and 33).

Gage (*op.cit.*, p.25, n.3) conjectures that Charles Turner was still working with the picture as late as the summer of 1806, this being the date of the earlier publication line on the first engraver's proof (see Rawlinson, 1908–1913, II, p.362). The print itself was not, however, finally published until January 1st 1807, when it included a dedication to 'Sir John Leicester Bart.' The following month Leicester exchanged the painting for the 'Fall of the Rhine at Schaffhausen' (B&J 61); 'The Shipwreck' was to remain in the artist's possession until his death.

Besides the main monochrome issue, coloured versions of the mezzotint were clearly envisaged right from the start, since they were specifically announced in the prospectus in which it was stated that they would be 'under the direction of the artist'. Moreover it seems clear that the coloured impressions were published on Turner's (rather than the engraver's) initiative. In the contract which he drew up with the engraver (Gage, *op.cit.*, no.10), Turner agreed 'To pay Mr C. Turner the price of 1. 6 [£1. 6 shillings] or trade price for all I want to colour', agreeing moreover 'not to part with any colourd print until 4 Months after the publishing of the proofs'. It is presumably the wording of this contract, especially Turner's phrase 'all I want to colour', which has given rise to the mistaken belief that the coloured impressions of the 'Shipwreck' were hand-coloured by Turner himself (they were stated to be so by Rawlinson, *op.cit.*, p.xxiv; more confusingly still, this impression was described as 'coloured by hand, probably not by Turner' when it was lent to the Royal Academy Bicentenary exhibition in 1975).

In fact the coloured impressions of the 'Shipwreck'

were printed in colour by the single-plate method, a highly skilful operation which would have been assigned to a professional colour printer, working under Turner's supervision. The artist would first have supplied the printer with a maquette of the colouring he required (the colouring of the print differs considerably from that of the painting). The plate would first have been inked with the ground tints (in this case blue and brown) and then local colour added (to the figures, for example) 'a la poupée' – that is laid in one by one with small rolls ('dollies') of cotton fabric (see Dyson, 1984, pp.155 and 221-2). Each coloured impression would have been inked up in the same way, as is confirmed by the survival of other impressions with similar colouring (for example that in the collection of William Drummond). Rawlinson argued that coloured impressions were only taken 'after the plate had become worn in printing' (op.cit., II, p.362), but this theory is disproved by the fact that this impression is in the second state, and still retains much of the original 'burr'.

Indeed, the colouring of these plates is restrained, subtle and highly attractive, thanks no doubt to Turner's close supervision of the quality of the printing. The fact that he was seldom thereafter to allow coloured reproductions to be made after his work (the exceptions are listed by Rawlinson, op.cit., II, p.210 and pp.212-3) may have been due to the difficulty he appears to have experienced in retaining control over the coloured impressions taken from this plate. In July 1810, a few years after the coloured impressions of the 'Shipwreck' had been issued, Turner spotted such an impression in the window of a printseller in Fleet Street. He immediately wrote to Charles Turner (who presumably still owned the plate) asking him to explain how this had happened, since the engraver had 'expressly agreed that none should be coloured but by J.M.W. Turner *only*' (Gage, op.cit., no.35).

The publication of the 'Shipwreck' marked an important turning point in the artist's career. It was the first time that one of his paintings had been published in engraved form, and considerably enhanced his reputation (see the list of subscribers to the plate, cat.no.29). It also gave Turner his first direct experience in working with mezzotint, and seems to have played an important role in the evolution of the *Liber Studiorum* in 1807, for which mezzotint was chosen and Charles Turner taken on as chief engraver. Indeed, despite the large number of prints Charles Turner was later to engrave for the artist, it appears to have been the 'Shipwreck' which he held in highest esteem as a testimony to their collaboration over the years. For in 1852, only a year after Turner's death, Charles Turner published an engraved full-length portrait of the artist in which an impression of the 'Shipwreck' is conspicuously propped up on a

chair behind him (an impression of this stipple engraving is in the Tate Gallery, T04842; repr. Venning, 1985, p.304).

29 **Shipwreck No.1 sketchbook** 1806
Open at page with names of subscribers to the 'Shipwreck' plate, mostly inscribed in ink (some crossed through in pencil); opposite a study in pen and ink for 'The Shipwreck'
117 × 185
Turner Bequest; LXXXVII 2, 3
D05377, D05378

Turner's list of subscribers to the 'Shipwreck' plate (see cat.no.28), which continues on page four of this sketchbook, includes over seventy names. It is indeed a most impressive list. There are names of various influential members of the nobility and gentry, many of whom were already (or later to become) important patrons of the artist – Swinburne, Egremont, Essex and Fawkes, for example; fellow Academicians such as William Beechey, Thomas Stothard and John Soane (the latter two names appearing on the following page); and a number of younger artists as well, many of whom were members of the recently formed Society of Painters in Watercolours. The name of William Frederick Wells, for example, who was a founder member of the Society and a friend of Turner's – he is said to have suggested to him the idea of the *Liber Studiorum* – appears at the bottom of the list; it is bracketed with the names of other members of the Society, such as George Barrett, Francis Nicholson and John Varley, and with the words '5 sent to Wells', indicating that the latter was happy to help distribute impressions to his fellow subscribers.

THE 'LIBER STUDIORUM'
(cat.nos.30–40)

Of all the engraved series undertaken by Turner during his lifetime, it is the *Liber Studiorum* which has received most attention from scholars over the years. It was regarded by Rawlinson (1908–13, I, p.xxv), for example, as the most personal of all the artist's engraving projects. If for a modern audience the didactic character of the *Liber* may detract somewhat from its appeal (today many would probably hold the 'Little Liber' in higher esteem), nevertheless the *Liber* remains the most important of all the artist's ventures into printmaking.

The original inspiration behind the project seems to have sprung from Turner's friend and fellow landscape artist, William Frederick Wells (see under cat.no.29), who towards the end of 1806 is said to have persuaded the artist to undertake a work which would do him 'justice' in the public eye. The prospectus issued the following year announced 'Proposals for the publishing of one hundred Landscapes, to be designed and etched by J.M.W. Turner, R.A., and engraved in Mezzotinto. It is intended in this publication to attempt a description of the various styles of landscape, viz., the historic, mountainous, pastoral, marine, and architectural' (see Pye & Roget, 1879, p.23). The one hundred plates envisaged in the prospectus were to be published in twenty parts of five prints each. In the event, only seventy-one were published, in parts, between 1807 and 1819. Twenty other prints were started but remained unpublished (see cat.nos.37 and 39); and there are also a number of drawings by Turner in brown wash which, although never engraved, resemble his other preparatory drawings for the *Liber* (see cat.no.31) and may have been intended for it as well (Rawlinson, 1878, pp.170–8 but see also Finberg, 1924, p.xlviii).

It seems likely that Turner originally intended each part to contain an example of each of the five branches of landscape mentioned in the prospectus, which are abbreviated on the prints themselves to their initial letter: thus 'H' stands for Historical, 'M' or 'Ms' for Mountainous, 'P' for Pastoral, 'M' for Marine and 'A' for Architectural. However in practice this was never possible, since Turner subsequently invented a sixth category, 'EP'. Although he never defined the meaning of 'EP', it is clear that he envisaged it as a sub-category of the pastoral; today the interpretation 'Elevated Pastoral' is usually favoured over the other contenders, 'Epic' or 'Elegant Pastoral', since Turner was fond of using the adjective 'elevated' when referring to landscape (see for example under cat.no.11). 'EP' and Pastoral are the categories which occur with greatest regularity in the *Liber* (see under cat.no.35), and 'EP' is the branch in which Turner's characteristic landscapes seem most naturally to place themselves.

'EP' is also the category in which Turner's work comes closest to that of Claude. Indeed, Claude's *Liber Veritatis*, which has been engraved in the 1770s by Richard Earlom and published by Boydell, was an important model for the *Liber Studiorum*. Yet while Claude's 'Book of Truth' was intended as a register of his compositions, to safeguard them against imitations, Turner's *Liber Studiorum* was rather conceived as a way of promoting his work, a means of communicating with a far wider public than could be achieved through his paintings alone. The *Liber* was also intended to function in some respects as a manual for every young artist to learn from (Wilton, 1987, p.73) and seems indeed to have been influential on a rising generation of teachers of watercolour such as David Cox and John Varley (for its influence on the latter, see Pye & Roget, *op.cit.*, pp.40–4).

The *Liber* however was a financial failure, and seems to have been unprofitable from the start. Such attempts as were made to advertise it in the early days, a task which Turner delegated to his namesake Charles Turner (who engraved and published many of the early plates, see under cat.no.30), appear to have been ineffective. Turner wrote the following message to Charles Turner on a proof impression of the 'Lake of Thun' (R.L.15): 'Respecting advertizing you know full well that everything ought to have been done long ago!! I have not seen a word in the papers ... if you can get advertized anywhere DO SO ... the plates not done – not advertized, in short everything has conspired against the work' (quoted Finberg, 1924, p.60). Not only were the parts published erratically, but Turner deliberately failed to include proof impressions in the so-called 'proof' sets, in defiance of his obligations to the subscribers (see under cat.no.40). He also failed to offer sufficient discounts to the trade as an inducement to sell the work; he reduced Colnaghi's trade discount by stages from twenty per cent to ten per cent, to five per cent, and finally to nothing at all (Pye & Roget, *op.cit.*, pp.73–4). The final demise of the project in 1819, however, was probably due to personal circumstances. By 1819, and especially after his return from Italy, Turner's ideas and tastes had changed, and other projects such as *The Rivers of England* are likely to have approximated more nearly to his ideas about engraving in the 1820s (see Colnaghi, 1975). Indeed some of the later, unpublished plates of the *Liber* (for example, R.L. 81, 84 and 86) show him experimenting with more dramatic subjects and working almost in pure mezzotint, perhaps indicating his frustration with the formula

of etching and mezzotint which had been adopted for most of the published plates.

The experience of working on the *Liber* over a period of twelve years, however, proved invaluable to Turner. During that period he took on and trained an important new group of talented mezzotint engravers, whose previous experience had in most cases been limited to portraiture (see under cat.nos.35–6). Many of them indeed – Lupton, Say and Charles Turner for example – were to make substantial contributions to subsequent engraving projects after his work, especially for the *Rivers* and *Ports of England* series of the 1820s (see cat.nos.41–2 and 44–7). Most of all, however, Turner's firm determination to oversee and control the quality of the work as closely as possible necessitated his mastering a wide range of printmaking techniques himself, enabling him to supervise the interpretation of his work with greater insight in future years. As well as experimenting with aquatint and soft-ground etching (see under cat.nos.32–3, 37 and 39) he learned to master the arts of etching and mezzotint. His outline etchings for the *Liber* (see cat.no.32) have been greatly praised (see Rawlinson, 1878, pp.xv-xviii and Finberg, 1924, pp.lii-liii), while the skill with which he had learned to use mezzotint during these years (see cat.no.34) helped prepare the ground for the 'Little Liber' prints of the following decade (see cat.nos.48–55).

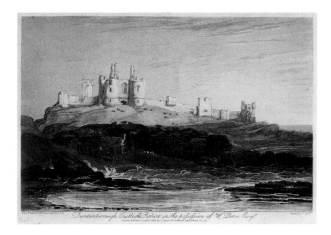

J.M.W. Turner and Charles Turner

30 **Dunstanborough Castle*** 1808
for the *Liber Studiorum* (Part III)
Etching, aquatint and mezzotint printed in brown ink, first state (R.L.14): 181 × 264; 292 × 433; 208 × 290
Engraved inscriptions: above, 'A'; below, *Drawn & Etched by J.M.W. Turner Esq*. *R.A.P.P.* and *Engraved*

by C. Turner, and *Dunstanborough Castle the Picture in the Possession of W. Penn Esq*.; lower left, *Proof*; and bottom centre, *London Published June 10. 1808. by C. Turner No. 50. Warren Street. Fitzroy Square.*
A00938

The first twenty of the seventy-one published plates of the *Liber Studiorum* were all engraved by Charles Turner, appearing in part numbers one to four between June 1807 and March 1809. Of these, parts two to four were published by him as well, from his address in Warren Street, Fitzroy Square, as the plate of the 'Shipwreck' had been in January 1807 (see cat.no.28). In 1809, however, the artist and engraver quarrelled over payment, Turner refusing to grant the increase from eight to ten guineas which Charles Turner demanded (Pye & Roget, 1879, p.59). Turner was thus obliged to take on other mezzotinters (such as Say and Lupton, see under cat.nos.35–6) to engrave the remaining plates in the series, all of which were now published from the artist's gallery in Queen Anne Street (cat.nos.33–6). Charles Turner claimed that his rift with Turner lasted nineteen years (Pye & Roget, *op.cit.*, p.60), but other evidence suggests that the two men were reconciled by the early 1820s, even as early as 1814-15 (see Gage, 1980, pp.290–91 and also under cat.no.42). Nevertheless it is still unclear whether the four other plates Charles Turner contributed to the *Liber* (R.L.26, 57, 65 and 74) were engraved before or after the quarrel (see Gage, *ibid*, but also A. Whitman, *Charles Turner*, 1907, pp.11–12).

'Dunstanborough' is one of the two plates by Charles Turner in part three of the series in which both mezzotint and aquatint were used (the other is 'The Bridge in the Middle Distance', R.L.13). In both cases aquatint was chiefly reserved for the sky, although here the engraver has carried the grain down to the rocks below and on sections of the right-hand tower of the castle, so as to help blend it with the rest of the mezzotinted plate (see fig.4). Turner was prompted to comment: 'Sir, You have done in aquatint all the Castle down to the rocks; Did I ever ask for such an indulgence?' (Finberg, 1924, p.56, records this inscription on a proof impression of the plate now in the Museum of Fine Arts, Boston). This comment has sometimes been interpreted to mean that Turner objected to the use of aquatint in this plate altogether, whereas in fact his objection simply lay with its being carried beyond the area of the sky. In fact Turner seems first to have sanctioned the use of aquatint in the *Liber* because of his desire to obtain finer and lighter skies which might wear better in the printing (Finberg, *op.cit.*, p.lviii). The first of the plates which Turner himself engraved for the series, 'Junction of Severn and Wye' (pub. June 1811,

part VI; R.L.28), shows him experimenting with aquatint in the sky area alone. Later on, however, Turner was often tempted to try using aquatint all over the plate and in a more random fashion (as, for example, with 'Kirkstall', cat.no.33, or 'Sand Bank with Gipsies', cat.no.39), and as Finberg had pointed out, the results were not entirely successful.

It used to be thought (and is sometimes still mistakenly thought) that Turner originally planned to publish the whole of the *Liber* in aquatint. This assumption was based on the premise that F.C. Lewis's plate, 'The Bridge and Goats' (R.L.43), in which both aquatint and mezzotint are employed, was the first subject to be engraved. However, Finberg pointed out that 'Bridge and Goats' was not in fact engraved until December 1807, six months after the first part of the series had already appeared (*op.cit.*, p.lvii, and Gage, 1980, no.21). 'Dunstanborough' was probably engraved after 'Bridge and Goats' (despite being published earlier, see Finberg, *op.cit.*, p.lxix), in which case it would have been the last plate in the *Liber* by an engraver other than Turner himself in which a combination of aquatint and mezzotint was used.

In 1798 Turner painted two versions of Dunstanborough Castle in oil, one now in Melbourne (B&J 6), the other in Dunedin, New Zealand (B&J 32). As Evelyn Joll (1988, p.6) has pointed out, the version of the subject engraved for the *Liber Studiorum* (the preparatory drawing is TB CXVI Q) contains elements from both these pictures, but is nevertheless closer to the Dunedin version. It is thus surprising that the engraving is inscribed with the name of the owner of the Melbourne version, 'Picture in the possession of William Penn Esq'.

31 **Crypt of Kirkstall Abbey** *c.*1808
Watercolour with pen and brown ink
181 × 252
Turner Bequest; CXVII O
D08142

Turner made preliminary drawings in pen and ink and monochrome washes for most of the *Liber* subjects many of which, like this one, are in the Turner Bequest (see Finberg, 1909, I, pp.315-24); according to Rawlinson (1878, p.vii, n.1), they were widely copied by students in the second half of the nineteenth century when on regular exhibition at the National Gallery. Of all the preparatory drawings made by Turner specifically for translation in engraved form, only those for the *Liber* were in monochrome. Since the project was partly conceived in imitation of Claude's *Liber Veritatis*, it seems likely that Turner's decision to make these preliminary drawings in brown and grey washes was similarly inspired by Claude, whose own drawings were usually executed in that medium.

Turner's preliminary designs are mostly the same size as the final mezzotints and usually in the same direction. In some of the earlier plates, however, the engraver failed to reverse Turner's image on the plate, with the result that the print was in the opposite direction from the preliminary drawing (see Finberg, *op.cit.*, I, pp.315-24 *passim* and also under cat.no.37).

Although some subjects were invented by Turner specifically for the *Liber* (for example, cat.no.34), a large number were adapted from existing pictures or sketches. This drawing, for example, is closely based on a watercolour (W.234) which Turner exhibited at the Royal Academy in 1798 and was later purchased by Mrs Soane for her architect husband, Sir John. Nevertheless it differs from the original watercolour in the grouping of the cows near the left-hand column, a detail modified still further by Turner in the etching and finished mezzotint of the subject (cat.nos.32-3).

32 Crypt of Kirkstall Abbey 1812
for the *Liber Studiorum* (Part VIII)
Etching, with a faint tone of aquatint and rocked in
parts (R.L.39): 179 × 262; 289 × 379; 209 × 289
A00988

At an early stage in the genesis of the *Liber*, Turner
decided to take on the task of etching the outlines of the
designs himself, probably so as to ensure their quality
(see Finberg, 1924, p.xlix). The etched lines were made
before the mezzotint work was added. First Turner
would require his engraver to lay the etching-ground on
the plate and then lightly trace the lines of his design;
then he himself would draw the lines with the etching
needle, evidently working fairly freely and at some
speed (Finberg, *ibid*). The 'biting in' of the lines and the
pulling of the proof impressions – which average eight
for each plate – would then be entrusted to the
engraver. The etchings were not intended for public-
ation, and mostly remained in Turner's possession
(Christie's sales, see under cat.no.7).

The etched outlines of the *Liber* subjects vary con-
siderably, which may partly be explained by the fact
that they were 'bitten in' by different engravers, as
Seymour Haden suggested to Rawlinson (Rawlinson,
1878, p.xiv). Although Turner did not execute all the
etched outlines of the *Liber* subjects, the lettering on the
final prints themselves – this one, for example, is
inscribed 'Drawn Etched & Engraved by I.M.W.
Turner ...' (see cat.no.33) – indicates that he was
responsible for the majority.

This is a particularly interesting and unusual
example of one of the preliminary etchings for the *Liber*,
since it also shows work by Turner with the mezzotint
rocker as well as the addition of a faint layer of aquatint
tone across the entire plate. It is very probably one of
the twelve impressions of this state that appeared in the
Turner sale in 1873 (Finberg, *op.cit.*, p.155).

33 Crypt of Kirkstall Abbey 1812
for the *Liber Studiorum* (Part VIII)
Etching and mezzotint printed in brown ink, first
state (R.L.39): 181 × 264; 300 × 441; 211 × 292
Engraved inscriptions: above, 'A'; below, *Drawn
Etched & Engraved by I.M.W. Turner Esqr. R.A.P.P.*,
centre, *Original Drawing in the possession of John Soane
Esqr. R.A. Professor of Architecture | '23 Ins. by 36 Ins.';*
and bottom, *Published Feby. 11 1812, By I.M.W.
Turner, Queen Ann Street West.*
A00989

Eleven of the published plates in the *Liber Studiorum* were
engraved entirely by Turner himself. He seems only to
have started working on the tonal parts of the design
after his quarrel with Charles Turner (see under
cat.no.30) probably – it has been suggested – because
other engravers were less expert at interpreting his
drawings. He already had some experience of the
mezzotint process from supervising the production of
Charles Turner's print of the 'Shipwreck' (see under
cat.no.28).

The first plate by Turner, published in 1811 in part
six, was the 'Junction of Severn and Wye' in a mix-
ture of mezzotint and aquatint (see under cat.no.30).
Each subsequent part (the last part, no.XIV, was
published in 1819) included one print by Turner,
while the twelfth part had two. As has already been seen
(cat.no.32), an aquatint ground has been applied all
over this plate, and like two later plates by Turner,
'Inverary Pier' and 'Calm' (R.L.35 and 44), shows him
combining the two processes of mezzotint and aquatint
in a rather haphazard and experimental way (see also
under cat.no.30). Nevertheless, as Finberg has argued
(1924, p.lx), Turner usually 'pulled them [the plates]
round in the end' and, indeed, Kirkstall is among the
most attractive prints in the whole series.

34 **Aesacus and Hesperie** 1819
for the *Liber Studiorum* (Part XIII)
Etching and mezzotint printed in brown ink, first
state (R.L.66): 178 × 257; 264 × 408; 209 × 289
Engraved inscriptions: above, 'H'; below, *Drawn
Etched & Engraved by I.M.W. Turner Esq R.A.P.P.*,
and title 'AESACUS AND HESPERIE' | *Vide Ovid
Met.* Book XI, and bottom, *Pub. Jan 1. 1819 by
I.M.W. Turner Queen Anne Street West.*
A01139

Aesacus, the son of King Priam of Troy, fell in love with
the nymph Hesperia. Seeing her one day drying her
hair by the River Cebren – which Turner here depicts
running through a leafy glade – Aesacus pursued her
but she, fleeing, was bitten on the foot by a snake and
died. Aesacus, mortified by guilt, lept into the sea to
drown himself, but was turned into a water bird by
Tethys, wife of Oceanus, ruler of the sea. This is one of a
number of drawings of mythological and biblical
subjects belonging to the 'Historical' category of the
Liber which were made especially for the project by
Turner; others were adapted by the artist from existing
oil paintings. Ruskin particularly admired it for the
quality of the tree drawing (*Modern Painters*; see Rawlin-
son, 1878, p.133–4).

After experimenting with a combination of aquatint
and mezzotint in many of the earlier plates Turner
made for the *Liber* (for example cat.no.33), in the later
published plates he tended to revert to mezzotint and
etching alone. This plate, which was not published until
1819, shows the considerable strides he had made over
the years in mastering the mezzotint process. In its
technical dexterity – the vivid and skilful rendering of
the passages of light and shade, and the rich, velvety
texture of the mezzotint – it anticipates the 'Little
Liber' plates of the next decade.

J.M.W. TURNER AND WILLIAM SAY
(1768–1834)

35 **Isis*** 1819
for the *Liber Studiorum* (Part XIV)
Etching and mezzotint printed in brown ink, first
state (R.L.68): 179 × 261; 295 × 433; 209 × 291
Engraved inscriptions: above, 'EP', below, *Drawn
& Etched by I.M.W. Turner Esq. R.A.P.P.*, and
*Engraved by W. Say Engraver to H.R.H. the Duke of
Gloucester*, and title 'ISIS' | *Picture in the Possession of
the Earl of Egremont. 3 Feet by 4 Feet*; and bottom *Pub.
Jan 1 1819 by I.M.W. Turner Queen Anne Str. West.*
A01143

The classifications 'EP' (probably 'Elevated Pastoral',
see above) and 'Pastoral' boasted the highest propor-
tion of published plates out of the six categories into
which Turner divided landscape for the *Liber*. An 'EP'
and 'Pastoral' subject were published in each of the
fourteen parts, and they thus number fourteen each out
of a total of seventy-one published plates (there were
twelve 'Mountainous', eleven 'Architectural', eleven
'Marine' and eight 'Historical'). The two were invari-
ably issued in pairs, representing two different aspects of
the pastoral: 'EP' aspiring to a poetical ideal, and
modelled more often than not on the landscapes of
Claude; and 'P' devoted to what has been described as
'the more prosaic realities of British rural life' (Pye &
Roget, 1879, p.28).

This plate, which as the lettering indicates was
adapted from an oil painting in the collection of
Turner's patron, the Earl of Egremont (and still today
at Petworth, see B&J 204), was published in 1819 in the
fourteenth and last part of the *Liber*; its pastoral
counterpart was 'East Gate Winchelsea, Sussex' en-
graved by S.W. Reynolds (R.L.67). 'Isis' is one of the
finest of the prints engraved for the *Liber* by William
Say, who was first employed by Turner after the artist's
quarrel with Charles Turner. Say was responsible for

eleven of the published plates in the series (and two of the unpublished ones), a total second only to Charles Turner's contribution. Like the latter, Say had little experience of engraving landscape when he first became involved in the project, most of his previous engraved work being in portraiture. The prints he engraved for the *Liber* were almost his only landscape work, although he was later to engrave two plates for *The Rivers of England* (R.760 and 765), which were amongst the earliest landscapes to be engraved in mezzotint on steel; indeed Say's son claimed his father was the first mezzotint engraver to work on steel, although Lupton has tended to take the credit for fully exploiting this innovation.

Lupton was the youngest of the engravers employed by Turner on the *Liber*. In a letter written to John Pye (transcribed in Pye & Roget, 1879, pp.64–5), he explained how he first became involved in the project. On applying for work from the artist, Lupton was offered as a test of his engraving skills a 'beautiful drawing in bistre of Solway Moss'; on the strength of the resulting mezzotint (R.L.52) – the first engraving to bear his name – he was immediately placed 'among my brother scrapers'. Lupton went on to engrave three more of the published plates for the *Liber*, of which 'Ben Arthur' is one, as well as several of the unpublished plates. Nevertheless his remuneration did not, apparently, enable him to print more than the basic number of proofs (Lupton to Pye; see Pye & Roget, *op.cit.*, p.63). He later worked with Turner on *The Rivers of England*, *The Ports of England* and *Marine Views* (see cat.nos.41–7).

J.M.W. TURNER AND T. LUPTON

36 **Ben Arthur, Scotland** 1819
for the *Liber Studiorum* (Part XIV)
Etching and mezzotint printed in brown ink, first
state (R.L.69): 184 × 267; 296 × 435; 210 × 290
Engraved inscriptions: above, 'M'; below, with title
and *Drawn & Etched by I.M.W. Turner Esq.
R.A.P.P.* and *Engraved by T. Lutton* [sic]; and
bottom, *London. Pub. Jan 1. 1819 by I.M.W. Turner
Queen Anne Str. West.*
A01145

Turner made a number of studies of Ben Arthur on his Scottish tour of 1801; there are pencil studies in the *Tummel Bridge* sketchbook (TB LVII) as well as in the 'Scottish Pencils' series (TB LVIII). No preliminary drawing, however, is known for this plate, which was published together with 'Isis' (cat.no.35), in the last and final part of the series. Rawlinson (1878, p.138) admired the 'sweeping mountain curves', the 'fleecy clouds' and the 'grand gloom' of the storm at the head of the ravine.

ATTRIBUTED TO J.M.W. TURNER

37 **Flounder Fishing, Battersea** ?c.1815
for the *Liber Studiorum* (unpublished plate)
Mezzotint and aquatint printed in brown ink,
touched proof (R.L.89): 179 × 253 approx;
220 × 296; 216 × 292
Inscribed: in pencil below image, 'M.C. Clarke';
'touched proof' and 'HV' [Henry Vaughan]
Trustees of the British Museum, 1900-8-24-96
(Vaughan Bequest)

Of the twenty unpublished plates of the *Liber Studiorum*, about half are generally thought to be by Turner, although some of the attributions to him are rather tentative. This plate, for example, was described by both Rawlinson and Finberg as 'probably' by Turner. However, two features in particular suggest a firmer attribution to the artist. Firstly, this unique engraver's proof shows the use of both mezzotint and aquatint (the

sky is worked with a fine film of aquatint grain), a combination used in the *Liber* mainly by Turner himself, and exclusively by him after about 1812 (see under cat.no.30); and secondly this early proof impression was pulled before the margins had been wiped clean, which would tend to point to its being an experimental plate by Turner rather than one made by a member of his professional team of engravers.

No preliminary drawing made expressly for the subject is known. However, it appears to have been adapted from an upright watercolour which Turner exhibited at the Royal Academy in 1811, 'November: Flounder-Fishing' (w.491), which similarly shows old Battersea Bridge in the distance. If Turner did use the 1811 watercolour, however, he departed from his usual practice of reversing images intended for the *Liber* when copying them onto the plates, so that this final design is in the opposite sense (see also under cat.no.31).

The inscription 'M.C. Clarke' on this impression refers to Mary Constance Clarke who inherited the celebrated collection of *Liber* prints assembled by Turner's stockbroker, Charles Stokes. She subsequently offered the collection to the British Musueum for £5,000, but her offer was rejected and the collection was then entrusted to Turner's agent, Griffith, in whose hands it was broken up (see Pye & Roget, 1879, p.93). This impression later entered the British Museum's collection through the Bequest of Henry Vaughan.

ATTRIBUTED TO J.M.W. TURNER

38 Copper Plate for 'Flounder Fishing, Battersea' ?*c*.1815
(unpublished plate for the *Liber Studiorum*)
217 × 294
NO2782

Eleven of the copper plates for the twenty unpublished subjects of the *Liber* were found amongst Turner's property in Queen Anne Street at his death in 1851 (another one, for 'Dumbarton Rock', R.L.75, was still in Lupton's possession at that date, see Finberg, 1924, p.302). Most of them were dispersed after his death (Christie's sales, see under cat.no.7). This plate was purchased at that sale by John Heugh for £8 eight shillings. It later came into the possession of William White who presented it to the National Gallery in 1910; after being placed on deposit at the British Museum, it has only recently been transferred to the Tate Gallery.

The plate was reworked after the early impression, cat.no.37, was taken; the sky in particular, which in that impression was executed in aquatint alone, was later reworked with the mezzotint rocker, as can be seen by closely examining the plate. A number of impressions were taken after this reworking, one of which is in the Tate Gallery (A01157).

The copper plates for the seventy-one published subjects of the *Liber* were all destroyed at Christie's before the Turner sales (see Christie, March 24, 1873 and under cat.no.7). However, forty-nine were subsequently resoldered and are now in the British Museum (1945-12-8-321 to 367, corresponding to R.L.2–50); some bear on their versos the name of the artist's supplier, G. Harris, no.31 Shoe Lane, London, who was later to supply Turner's steel plates (see under cat.no.52).

39 Sand Bank with Gipsies *?c.*1815–20
for the *Liber Studiorum* (unpublished plate)
Soft-ground etching with aquatint printed in black
ink (R.L.91): 179 × 256; 246 × 352; 217 × 303
Trustees of the British Museum, 1913-4-15-31

Two of the unpublished plates from the *Liber* are etched
by Turner in soft-ground – this print and 'Narcissus and
Echo' (R.L.90). Only three impressions of 'Sand Bank'
are known, two in pure soft-ground etching, and this
unique later impression in which the artist has super-
imposed a second layer of tone, probably aquatint. The
results here are not entirely successful. The aquatint
ground has all but obscured the rich chalky effect of the
soft-ground below, and close examination of the bank-
ing to the right of the print reveals areas of foul biting.
This may explain why Turner subsequently abandoned
the plate.

The subject of this print is closely modelled on an oil
painting by Turner in the Bequest (B&J 82; Reserve
Gallery 1), which he may have exhibited at his own
gallery in 1809. It is strongly reminiscent of Thomas
Gainsborough, whose work Turner was fond of imitat-
ing in the early years of his career (see B&J 45 and 77).
As a young boy, Turner made a copy of an etching by
Gainsborough, 'Wooded Landscape with Church, Cow
and Figure' (see Hamlyn, 1985, p.22–3 and Hayes,
1970, pls.30 and 32). It seems likely that he would have
known other engravings by Gainsborough, including
those dating from the mid- and later 1770s which were
executed in a combination of aquatint and soft-ground
etching (see Hayes, *op.cit.*, pp.15ff). It would be entirely
characteristic of Turner's desire to emulate his eminent
precursors in landscape art that in a print obviously
indebted to Gainsborough for its subject-matter he also
made a unique experiment with a combination of
techniques particularly associated with that artist's
prints.

**40 Blue Paper Wrapper for the *Liber
Studiorum***, part no.VII
311 × 504
Inscribed by Turner in red ink: 'Proof', '7', and
with his monogram signature 'IMWT'
Iain Bain

All fourteen published parts of the *Liber Studiorum* were
issued in blue paper covers, each containing five prints
(except for part number ten which had a sixth print, the
frontispiece, included *gratis* to subscribers). This part,
number seven, was issued in June 1811 and included
prints by Robert Dunkarton, J.C. Easling, Say (see
under cat.no.35), T. Hodgetts and Turner himself. The
wrapper bears the words 'Liber Studiorum; Illustrative
of Landscape Compositions, viz. Historical, Moun-
tainous, Pastoral, Marine and Architectural, by J.M.W.
Turner R.A.', and gives details of the price for that part
and the subscription address. The price on this wrapper
is given as fifteen shillings for prints and £1 and five
shillings for proofs, which would imply that the increase
in price to a guinea for prints and two guineas for proofs
did not take place until after 1811 (the price had
certainly risen by 1816 when part numbers XI and XII
were advertised at the higher rate, see Finberg, 1924,
p.xxxv. There is no concrete evidence to support
Wilkinson's suggestion, 1982, p.14, that the increase
took place in 1809). On the other hand, it is also stated
on the wrapper that subscriptions would be 'received at
C. Turner's, 50 Warren Street, although by 1811,
following his quarrel with the engraver (see cat.no.30),
Turner had himself taken over responsibility for the
publication of the *Liber* as well as for the receipt of
subscriptions. It would appear, then, that in this
instance, Turner was using up an old wrapper.

Turner himself then filled in the part number on the
wrapper, and added his initials. He used black ink for
print impressions, and red for proofs; sometimes in the

latter he added the word 'proof' in the upper left hand corner, as in this example. Despite the fact that subscribers paid a premium for proof impressions, they rarely – if ever – appear to have received a set made up completely of fine impressions. Indeed, according to C.F. Bell (1903,p.ix), probably only one proof at best was ever included in such 'proof' sets. Of the 5,000 or so *Liber* prints found in Turner's studio on his death, about 2,000 were described as of excellent quality, a comment that would indicate that they must have been proofs. This total would yield an average of twenty-eight proofs for each of the seventy-one published plates, and since each plate was only capable of producing about twenty-five to thirty proof impressions, it is clear that Turner had kept most of them back. Bell argued (*ibid*) that Turner would not easily have managed to dupe an increasingly discerning public, and that this less than honest practice must have been one of the reasons for the demise of the *Liber* project. Nevertheless, as Turner himself began to pass off ordinary print impressions as proofs, it must have become increasingly difficult for the public to know exactly what they were buying, as John Pye observed (Pye & Roget, 1879, p.69).

Despite the failure of the *Liber* to sell in the earlier part of Turner's career, from 1840 to 1851 good impressions became greatly sought after by collectors (see Pye & Roget, *op.cit.*, p.75). The individual part numbers began to be broken up, so that fine impressions could be separated from poor ones. Although many of the *Liber* wrappers still survive, it is rare to find one with the five prints still stitched into the cover.

THE 'RIVERS', 'PORTS' AND 'MARINE VIEWS' (cat.nos.41–7)

The Rivers of England series seems to have been planned by W.B. Cooke in the early 1820s as a sequel in mezzotint to the *Southern Coast* (see cat.nos.1–5 and 12–13), which was still at that date in the course of publication, the last part appearing in 1826. Both series were abandoned after Turner's final quarrel with Cooke in 1827, chiefly occasioned by Turner's demand that the increase in his fee from seven and a half guineas to ten guineas, negotiated in 1817 after the first four numbers of the *Southern Coast* had appeared, should be backdated to include the earlier drawings as well (see Gage, 1980, no.121, pp.104–6 and under cat.no.43). With *The Rivers of England* series, however, Turner chose rather to loan out (rather than to sell) his drawings to Cooke, for a fee of eight guineas each. All eighteen watercolours (w.732–49) remained in his studio until his death, thus forming part of the Turner Bequest. Like the preliminary designs made by Turner for the *Southern Coast* series, however, they were also made on the same scale as the subsequent engravings.

The Rivers of England seems to have been the first landscape series to be engraved on steel (see Rawlinson, 1908–13, II, p.363). Of the six engravers employed, four – Lupton, Charles Turner, Say and S.W. Reynolds – had already worked with Turner on the *Liber Studiorum*. The *Rivers* was originally intended to comprise thirty-six plates, published in twelve parts of three prints each. When it was prematurely brought to a close in 1827, however, only seven parts had appeared. And of the twenty-one prints published, only sixteen (R.752–67) were after Turner; of the two other projected subjects, 'Arundel Castle' (R.768) was never finished and 'The Medway' (though listed R.769) was never engraved for this series. Four subjects, 'York Minster', 'Kirkstall Abbey', 'Ripon Minster' and 'Bolton Abbey', were after Girtin and one, 'Eton on the Thames', was after William Collins.

The seventh and final part number of the series, however, listed only eighteen subjects in the contents list, explaining in the 'Directions to the Binder' that three prints – Collins's 'Eton', Girtin's 'Ripon', and Turner's 'Totnes' (R.767) – had had to be cancelled owing to 'imperfections in the manufacture of the steel-plates on which they have been engraved. This accidental circumstance, in the early invention of Steel Mezzotinto Plates, defeated all the exertions made by the Artists to restore them' (advertisement bound in a copy of the seventh issue, private collection). Nevertheless, in practice, the cancelled plates sometimes con-

tinued to be included in bound copies of the work, which was published in 1827 under the new title *River Scenery*.

Two of the cancelled plates, 'Eton' and 'Ripon', had been engraved by Lupton who in 1822 had been awarded the Isis Gold Medal of the Society of Arts for his success with a soft steel plate. This plate apparently yielded 15,000 impressions and had been developed after much experimentation with nickel and various alloys. The steel plate, however, required much more work. In a letter to the Society of Arts dated 1 November 1822, Lupton compared the number of times is was necessary to go over the plate with the rocker when preparing the mezzotint ground; for copper it was between twenty-four and thirty-six times, for steel as many as ninety (Beck, 1973, p.19).

The lettering on most of the prints from *The Rivers of England* series includes in their published states the words 'Engraved on Steel', as do two other prints by Lupton engraved after Turner at this date, 'The Eddystone Lighthouse' (cat.no.43) and 'Sun-Rise. Whiting Fishing at Margate' (R.772). Both of these subjects were published by W.B. Cooke for a series entitled *Marine Views*, which like *The Rivers of England* foundered after Cooke's quarrel with Turner (see under cat.no.43); Eric Shanes (1981, p.10) has argued that other finished watercolours of marine subjects by Turner dating from the mid-1820s were probably intended for this series. The dramatic night scene of 'Eddystone', 1824, brilliantly rendered in mezzotint by Lupton, anticipates the subjects which Turner was to engrave himself a year or two later for the 'Little Liber', inspired no doubt by his collaboration with Lupton at this date.

About the time he was scraping the 'Little Liber' prints, Turner became involved in another project with Lupton in which mezzotint on steel was also used, *The Ports of England*. This series seems to have been planned as a sequel to *The Rivers of England*, though this time Lupton acted as publisher, his address at 7 Leigh Street, Burton Crescent appearing both on the wrapper (cat.no.44) and on the prints themselves (cat.nos.45 and 47); it was presumably also Lupton who arranged the French copyright (see under cat.no.45). Twelve plates were projected for the series, to be issued in six parts of two plates each. Details of the cost for each part number were given on the wrapper: prints were to cost £8 6d, proofs on French paper £12 6d and India paper proofs £14. The series was 'Dedicated with Permission to his most Gracious Majesty George the Fourth'.

By 1828, however, only the first six prints in the series had been published (see cat.nos.45 and 47). According to Rawlinson (1908–13, II, p.378), the remaining six prints (R.785–90) were nearly finished by that date; but

it was not until 1856 that they were published, by Gambart & Co., alongside the others in the series under the new title *The Harbours of England*, with accompanying text by Ruskin. The series does not seem to have been abandoned through any specific disagreement between Turner and Lupton, but simply to have ground to a halt through their 'reciprocal indulgence of delay', as Ruskin put it in his preface to *The Harbours of England*. Indeed it was through close collaboration with Lupton in reissuing *The Ports of England* that Ruskin gained a number of valuable insights into Turner's supervision of his engravers, concluding that Lupton in particular was more often 'tormented than helped by Turner's alterations' (see under cat.no.47). Nevertheless Lupton seems to have remained on good terms with Turner throughout his life, and to have retained a great respect for him (see Gage, 1980, pp.266–7).

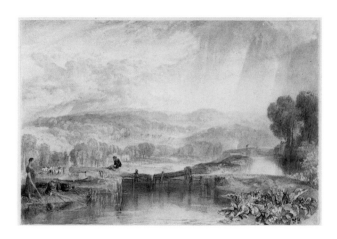

41 **More Park** *c.*1823
Watercolour with scraping-out
158 × 221
Turner Bequest; CCVIII H
D18141

By the 1820s Turner had evolved a meticulous technique for watercolours designed to be translated into prints that was characterised by layers of tiny brushstrokes by which he could convey the maximum detail and expression on a small scale. This is one of the drawings he loaned to W.B. Cooke to be engraved for *The Rivers of England*, and indeed is one of the most delightful in that series. It shows Turner's mastery of atmospheric effect; shafts of light burst through the passing cloud and cast a sparkling freshness across the entire landscape.

The foreground is occupied by a section of the Grand Union Canal, with Lot Mead Lock in the centre; the

river Colne – supposedly the subject of the watercolour – runs beyond and below the canal to the left (see Shanes, 1981, p.30). Nestling between the trees on the far distant hillside one can just make out the entrance facade of Moor Park with its four-column portico in the centre, a detail rendered more crisply in the engraving (cat.no.42). The house owes its present appearance to James Thornhill who, though best known as a decorative painter, was employed in the 1720s by the merchant Benjamin Styles to remodel the existing house in a Palladian style.

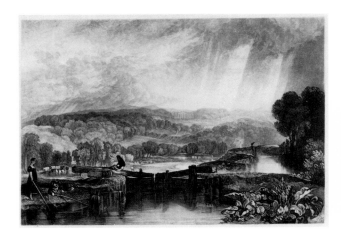

C. TURNER AFTER J.M.W. TURNER

42 **More Park, near Watford, on the River Colne** 1824
for *The Rivers of England*
Mezzotint on steel printed in black ink, engraver's proof b) (R.754): 156 × 222; 340 × 500; 194 × 255
T04795

The published state of this print, plate number four in *The Rivers of England* series (this is an engraver's proof before letters), bears the words: 'Engraved on steel by Chas Turner. Engraver in Ordinary to His Majesty'. It is not clear exactly when Turner and Charles Turner were reconciled after their quarrel, although the date of this print proves that their rift could not have lasted as long as nineteen years as Charles Turner himself claimed (see under cat.no.30). Indeed Charles Turner engraved four other plates after his namesake for *The Rivers of England* in the early to mid 1820s, although one of these, 'Totnes', was subsequently cancelled due to imperfections in the steel plates (see introductory section above).

The letterpress on the original wrapper for the part issues of *The Rivers of England* claimed that 'the style in which the plates are engraved is peculiarly adapted to the powerful effects of light and shade, in the varieties of Twilight, – Sun-rise, – Mid-day, – and Sunset'. But while mezzotint is indeed an ideal medium for capturing the sharper contrasts of light and shade characteristic of night or twilight scenes, it is not in fact so suited to translating so brightly and evenly lit a daytime landscape as that of Turner's watercolour of 'More Park' (cat.no.41). Similarly, while mezzotint is excellent for breadth and mass, it is not so well adapted to the sheer quantity and proliferation of detail that distinguish Turner's landscape watercolours of this date. So despite the fact that this print is by one of the most skilled and experienced of Turner's engravers, many of the subtleties and most sparkling passages of the original watercolour – such as the myriad reflections in the water – are lost in the translation.

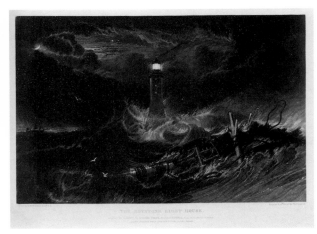

T. LUPTON AFTER J.M.W. TURNER

43 **The Edystone** [Eddystone] **Lighthouse** 1824
for *Marine Views*
Mezzotint on steel printed in black ink, third state (R.771): 210 × 313; 338 × 490; 266 × 360
Engraved inscriptions: below, 'Drawn by J.M.W. Turner Esq.r R.A.' and 'Engraved on Steel by Tho.s Lupton.'; and centre, 'THE EDYSTONE [*sic*] LIGHT HOUSE. / PLATE I. OF A SERIES OF MARINE VIEWS, BY J.M.W. TURNER, R.A. PUBLISHING SINGLY. / London. Published March 1, 1824, by W.C. Cooke, 9 Soho Square.'
T04820

As the lettering indicates, this was the first in a projected series of prints of *Marine Views* after Turner which were to be published individually. Wilton claims (1979, p.357) that 'Eddystone' was issued by Turner himself, in addition to the other print in the series, 'Margate' (R.772). This seems unlikely since W.B. Cooke's name

appears on the publication line for both prints. Indeed the fact that the series was abandoned in 1825 after only two subjects had been published can probably be explained by the worsening relations between Turner and Cooke which finally came to a head in January 1827. Indeed it is clear from Cooke's last letter to Turner that, following the artist's increasingly unreasonable demands for payment over the *Southern Coast* series, the last straw came when Turner asked for a two-guinea fee for the loan of his watercolour of 'Neptune's Trident' (etched, probably by Cooke himself, in 1825 for the wrapper of *Marine Views*) but which Cooke was in no doubt that Turner had '*presented*' him (Gage, 1980, no.121).

When Lupton was employed to work with Turner for *Marine Views*, he was already contributing plates to *The Rivers of England* (see cat.no.7) which, like this one, were all engraved on steel. Although Lupton was to engrave other mezzotints after the artist's work, for *The Ports of England* (cat.nos.45 and 47) as well as some large plates (R.791 and 798), this print is undoubtedly one of his masterpieces. Here the mezzotint medium is ideally suited to capturing all the inky blackness of this night-time scene, in which the only lights are created by the glow of the lighthouse itself, which vividly illuminates the tossing waves, and by the moon and glittering sparkle of the stars beyond; these areas of light are all the more brilliant by contrast with the rest of the tenebrous scene. It was exactly this sort of subject – stormy nocturnal scenes – which Turner was to engrave himself for the 'Litle Liber' a year or two later.

A reduced version of this plate was engraved by Lupton in 1829 (R.773). The original drawing is now lost. Shanes (1981, p.154) believed it was the same 'Eddystone' which was loaned to Cooke in March 1817 to be engraved for *The Rivers of Devon*, and thus that it was painted as early as circa 1817. However, it seems more likely that it was a smaller version of the subject, mentioned by Finberg (and discussed by Wilton, 1979, p.357) which was lent for that series, and that the original watercolour for this print was in fact painted by Turner especially for *Marine Views* in the early 1820s.

44 **Wrapper for *The Ports of England*** 1826
Grey-brown paper wrapper (front page only) for *The Ports of England*, 428 × 293: with etched vignette design after Turner (R.770), 160 × 130 approx, and inscribed with part number '1', and name of subscriber 'Saml. Oliver. Esq.'; and with advertisement for the series stitched inside
T04822

Just as he had provided vignette illustrations for the wrappers of Cooke's *Views in Sussex* (R.128) and the series *Marine Views* (R.770, see under cat.no.43), so also did Turner design the motif for *The Ports of England* wrapper. The preparatory watercolour (W.750; Fitzwilliam Museum) is inscribed with the title which appears to have originally been envisaged for the series, 'The Harbours of England', and under which it was reissued in 1856 with accompanying text by Ruskin, to whom the drawing once belonged.

The engraver of the wrapper vignette is not known, but is sometimes thought to have been Turner himself. An interesting proof impression of the vignette, however, in the British Museum (1891-6-17-72) is touched by Turner apparently in pencil alone (*pace* Ruskin's comment below) in the areas where the artist required the shadows to be darkened, and elsewhere annotated 'too strong'. Although Turner sometimes touched the proofs of engravings he made himself (see under cat.nos.48 and 53), Ruskin was in no doubt that the touchings on this proof were made by Turner for the interpretation of one of his engravers. For the proof is inscribed by Ruskin with the words: 'The pencil stands for enforcement of shade on the gun; for light on the

anchor if he touched with *lead* [presumably lead white, also known as Chinese white]. This was Turner's short-hand – understood by all his engravers. Turner's touched proof of the engraving of drawing given by me to Cambridge. J. Ruskin'. Turner used white chalk or scratching out as well as lead white to indicate to his engravers areas he wished to be lightened (see cat.no.5).

The lettering on this print includes (as do the other five in the series published between 1826 and 1828, see cat.no.47) the words of the French copyright ('Déposé à la Bibliothèque) and the name of the Parisian print-seller where it was available for sale. The preliminary watercolour for this subject is in the Turner Bequest (TB CCVIII Q).

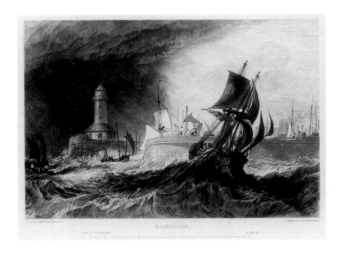

T. LUPTON AFTER J.M.W. TURNER

45 **Ramsgate** 1827
for *The Ports of England*
Mezzotint on steel printed in black ink, second state (R.782): 164 × 236; 343 × 438; 202 × 272
Engraved inscriptions: below, with title, names of artist and engraver and, centre, 'PORTS OF ENGLAND. PLATE IV. / London, Pub.d May 1, 1827, by Tho.s Lupton; 7 Leigh Street, Burton Crescent; Déposé à la Bibliothèque, et se vend à Paris chèz Shroth, Rue de la Paix, N.º 18.'
T04831

In the passage which he wrote to accompany this plate when it was reissued in 1856 under the title *The Harbours of England*, Ruskin commented: 'The lifting of the brig on the wave is very daring . . . and the lurid transparency of the dark sky, and wild expression of wind in the fluttering of the falling sails of the vessel running into the harbour, are as fine as anything of the kind he [Turner] has done'. Indeed, most of Turner's designs for this series depict similar blustery stretches of water close to the shoreline, with vessels either coming into port or putting out to sea (see cat.no.46). Only rarely does he concentrate on the activity within the port itself, although in this example a group of men can be made out on the quayside struggling to control windswept sails and rigging.

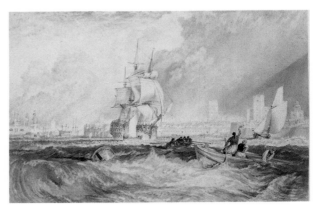

46 **Portsmouth*** *c*.1824
Watercolour
160 × 240
Turner Bequest; CCVIII S
D18152

Ruskin stated in the preface to *The Harbours of England* that one of the reasons he had agreed to write the accompanying text was because the series included four plates by Turner – this one and 'Sheerness', 'Scarborough' and 'Whitby' – which he considered 'among the very finest that had been executed from his marine subjects'.

The details of the various monuments depicted in this watercolour somewhat indistinctly – the towers, spires and cupolas of Portsmouth's churches and civic buildings – are rendered more clearly by Lupton in the subsequent engraving; and the small rowing boat which in the watercolour shows four passengers, in the engraving has five (see cat.no.47).

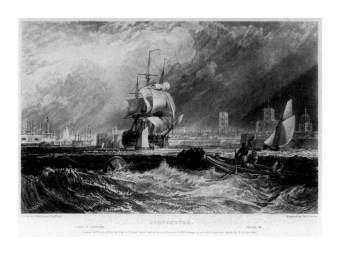

T. LUPTON AFTER J.M.W. TURNER

47 **Portsmouth*** 1828
for *The Ports of England*
Mezzotint on steel printed in black ink, second
state (R.784): 161 × 240; 300 × 446; 202 × 268
Engraved inscriptions: below, with title, names of
artist and engraver and centre, 'PORTS OF
ENGLAND. PLATE VI / London, Pub.ᵈ May 1, 1828,
by Thoˢ Lupton, 7 Leigh Street, Burton Crescent;
Deposé à la Bibliothèque, et se vend à Paris, chèz
Shroth, Rue de la Paix, N.º18.'
TO4834

One detail in particular which had been so well
rendered by Turner in the original watercolour for this
subject (cat.no.46), the rolling wave on the left, was lost
in the course of translation into the print. It is hard not
to sympathise with Ruskin's view in the accompanying
text to this plate in *The Harbours of England* that at least
in this instance Turner's near-obsessional habit of
touching the preliminary proofs defeated its own object.
Ruskin was, moroever, well placed to appreciate the
engraver's point of view, as well as the artist's, having
collaborated closely with Lupton in reissuing the plates.
Because of the great insight it offers into Turner's
working methods and his relationship with his en-
gravers, Ruskin's passage is worth quoting at some
length:

'The wave on the left hand beneath the buoy,
presents a most interesting example of the way in which
Turner used to spoil his work by retouching. All his
truly fine drawings are either done quickly, or at all
events straight forward, without alteration: he never, as
far as I have examined his works hitherto, altered but to
destroy. When he saw a plate look somewhat dead or
heavy, as, compared with the drawing, it was almost
sure at first to do, he used to scratch out little lights all
over it, and make it "sparkling;" a process in which the
engravers almost unanimously delighted [footnote:
'Not, let me say . . . the careful and skilful engraver of
these plates, who has been much more tormented than
helped by Turner's alterations], and over the impossi-
bility of which they now mourn, declaring it to be
hopeless to engrave after Turner, since he cannot now
scratch their plates for them. It is quite true that these
small lights were always placed beautifully . . . But the
original power of the work was for ever destroyed. If the
reader will look carefully beneath the white touches on
the left in this sea, he will discern dimly the form of a
round nodding hollow breaker. This in the early state of
the plate is a gaunt, dark, angry wave, rising at the shoal
indicated by the buoy; – Mr. Lupton has fac-similed
with so singular skill the scratches of the penknife by
which Turner afterwards disguised this breaker, and
spoiled his picture, that the plate in its present state is
almost as interesting as the touched proof itself; interest-
ing, however, only as a warning to all artists never to
lose hold of their first conception.'

THE 'LITTLE LIBER' (cat.nos.48-55)

The twelve mezzotints engraved by Turner himself for the 'Little Liber' (R.799-809a) are today considered his most original contribution to printmaking, and indeed some of the finest examples produced by any artist during the Romantic period. They are highly personal works, characterised by the extraordinary vigour and freedom of their execution. Yet, because they were never published in Turner's lifetime, their origin and purpose remains obscure.

All of the subjects for the 'Little Liber' show dramatically lit night or storm scenes, which in their strongly contrasted tones are ideally suited to the mezzotint medium. They are called the 'Little Liber' because they were engraved by Turner at some point after the *Liber Studiorum* was abandoned in 1819 (their alternative title is 'Sequels to the Liber Studiorum'). Despite this rather tenuous connection with the *Liber*, however, some of the later unpublished plates for that project scraped by Turner himself do seem to anticipate the 'Little Liber' subjects both in subject-matter and in handling: 'Stonehenge' (R.L.81), 'The Lost Sailor' (R.L.84) and 'Moonlight on the Medway' (R.L.86), for example, not only show an increasing preoccupation with dramatic light effects but also a tendency on Turner's part to dispense with etched outlines and to concentrate on mezzotint alone. With the 'Little Liber', however, the artist exploits the rich and velvety blackness of the mezzotint medium with an expressive power which is lacking from any of the *Liber* subjects (see Royal Academy, 1975, p.95); and etching is used sparingly, reserved for occasional details (see under cat.nos.50 and 55).

Most of the 'Little Liber' prints are based on broadly-handled colour sketches (cat.nos. 49, 51 and 54) rather than the more detailed preliminary designs with which Turner usually supplied the engraver. On stylistic grounds both watercolours and mezzotints are usually thought to date from the mid 1820s. The external evidence, moreover, tends to confirm such a dating. Some of the plates from the 'Little Liber' were engraved on steel, which was not generally used before 1820. Moreover in the mid 1820s Turner was working on the two series *The Rivers of England* and *Marine Views* (see cat.nos.41-3) in close collaboration with an engraver, Lupton, who had pioneered the use of steel plates only two or three years before. There is also the possibility that the 'Little Liber' series was inspired by the publication in 1826 of a mezzotint by F.C. Lewis after Francis Danby, 'Sunset at Sea after a Storm', which two of Turner's prints seem closely to resemble (see under cat.no.49). Whatever their exact date, however, the scraping of the 'Little Liber' prints seems to have played an important role in Turner's development as a colourist in the later 1820s and early 1830s.

Few impressions were taken of the 'Little Liber' prints in Turner's lifetime, and are now extremely rare. Two, cat.nos.50 and 52, have been borrowed for this exhibition from the fine holdings of the British Museum: other examples are in the Department of History of Art, University College, London; the Ashmolean Museum, Oxford; the Museum of Fine Arts in Boston; and the Yale Center for British Art in New Haven. Many of the plates, of copper and steel, were found in Turner's house on his death in 1851 (some of them are listed in one of the versions of the Turner sale catalogue for March 24-28, 1873, see under cat.no.7). The artist, however, had clearly failed to take the special care which Lupton noted (in a letter to the Society of Arts, 1 November 1822; quoted Beck, 1973, p.19) was necessary to prevent the steel from rusting, since all but two of the steel plates had badly corroded. (Steel plates were, or are still, known for R.801-3 and R.808; and since posthumous impressions of R.799 and R.807 show evidence of the corrosion of the plates, it may be safely assumed that they were also of steel. Copper plates were known for R.805-6 and 809; nothing, however, appears to be known about the plates for R.800, 804 or 809a). Nevertheless in the second half of the nineteenth century a certain number of impressions were taken from most of the surviving plates from the series: some (see under cat.nos.52-3 and 55) were taken by the printmaker Francis Seymour Haden (1818-1910) for Turner's executors shortly before the plates were dispersed in 1873; others, either on wove paper (cat.no.48) or on India paper (cat.no.53 and 55), were taken after the sale by the new owners of the plates, and vary considerably in quality.

48 **Paestum** *c*.1826
for the 'Little Liber'
Mezzotint on steel printed in black ink, late
nineteenth-century impression (R.799): 154 × 216;
255 × 345; 192 × 155
T04914

One of the chief features of this plate is the dramatic
lighting which forks across the sky from the right. In this
late nineteenth-century impression, however, the light-
ning is all but obscured by areas of corrosion which
show where the plate has rusted and indicating that it
must have been of steel rather than copper (according
to Rawlinson, 1908–13, II, p.385, this was not one of the
plates found in Turner's house at his death).

The watercolour which served as the preliminary
study for this print is in the Turner Bequest (TB
CCCLXIV 224; W.769). It appears to have been adapted
from pencil sketches in the *Naples, Paestum and Rome*
sketchbook (TB CLXXXVI) made by the artist when he
visited the site in 1819. The three fifth-century Doric
temples had been rediscovered in the mid-eighteenth
century; the site, although remote, was particularly
spectacular, the temples being situated in the middle of
a plain surrounded by mountains on three sides (Pow-
ell, 1987, p.83). In the watercolour, and in the early
proof impressions of the print which follow the water-
colour quite closely, Turner included only the temple to
the left, in an open but otherwise empty landscape. This
impression shows Turner's later alterations – the ad-
ditions of a second temple at right as well as the skeleton
of an animal in the foreground – and the reworking of
the sky with the burnisher. Most of these modifications
are indicated on an elaborately touched engraver's
proof, b), in the British Museum, donated by Rawlin-
son (1919–6–14–3).

49 **Shields Lighthouse*** *c*.1826
Watercolour
235 × 284
Turner Bequest; CCLXIII 308
D25431

Like another of the 'Little Liber' subjects, 'The Evening
Gun' (R.800), this design for cat.no.50 bears a striking
resemblance to the mezzotint engraved in 1826 by F.C.
Lewis after Francis Danby's painting, 'Sunset at Sea
after a Storm' (City of Bristol Museum and Art Gallery;
repr. F. Greenacre, *Francis Danby 1793–1861*, exhibition
catalogue, 1988–9, p.48). Indeed it has been suggested
that it was Danby's twilight scenes in general, and the
publication of Lewis's print in particular, which may
partly have inspired Turner to embark on the 'Little
Liber' series.

50 **Shields Lighthouse*** *c.*1826
for the 'Little Liber'
Mezzotint on steel printed in black ink, engraver's
proof c) (R.801): 152 × 212; 186 × 248 (trimmed
within plate-mark)
Trustees of the British Museum 1912-10-12-3
(presented by Henry Oppenheimer Esq.)

As was the case for many of the 'Little Liber' prints,
Turner modified the original design of this subject as he
progressed; many of the trial proofs which he pulled for
the 'Little Liber' series constitute new states. Three
states are known for this print: the earliest follows the
drawing closely, with the scene at its darkest, and the
various elements clearly defined by the light of the
moon, while appearing in strong contrast to each other;
in the second state the buoy was introduced and the
details were rendered less distinct as the plate was
lightened throughout; and in the third and final state, of
which this is an impression, the moon was reduced in
diameter, rays were added above, and etched lines were
added to the brig and buoy (see White, 1977, p.80).

 According to Rawlinson (1908-13, II, p.387), the steel
plate for this print was found completely corroded in
Turner's house at his death. Some impressions were
nevertheless taken from it in the late nineteenth cen-
tury. One, for example, is in the Tate Gallery (T04915)
and shows how the finely balanced chiaroscuro of the
design has all but disappeared due to the poor condition
and wear of the plate.

51 **Ship in a Storm** *c.*1826
Watercolour and pencil
242 × 300
Inscribed: in various parts of the sheet: '1', '2', '3',
'4', '5'
Turner Bequest; CCLXIII 309a
D25432

In contrast to the *Liber Studiorum*, for which Turner
made highly detailed preliminary pen and wash draw-
ings (see cat.no.31), for the 'Little Liber' he relied on the
very broadest of colour sketches like this one (see also
cat.nos.49 and 54). In later stages in the evolution of the
print, he was often tempted to add picturesque or rather
extraordinary details such as an animal skeleton in
'Paestum' (cat.no.48), a buoy in 'Shields' (cat.no.
50), or a hare and burdock leaves in 'Gloucester'
(cat.no.55). Here, however, only the elements of the
original drawing – a ship floundering in a storm-tossed
sea overshadowed by thunderous black clouds – appear
in the final print (cat.no.52), although they are ren-
dered more forcefully; the composition is blacker and
more dynamic, and the mood is considerably more
menacing.

 The numerals one to five are inscribed at intervals
throughout the design perhaps corresponding, it has
been suggested, to the main tonal blocks into which the
design divides itself (Wilton, 1980-81, p.149); they
might perhaps have provided useful guidance for
Turner when he was burnishing the plate.

52 **Ship in a Storm** *c.*1826
for the 'Little Liber'
Mezzotint on steel printed in black ink, engraver's
proof b) (R.803): 148 × 213 (trimmed to image)
Trustees of the British Museum, 1912-10-14-5

Unlike most of the other steel plates for the 'Little
Liber', that for 'Ship in a Storm' was found in excellent
condition after Turner's death. A number of im-
pressions were taken from it for Turner's executors by
the printmaker Seymour Haden shortly before the
Christie's sales (see under cat.no.7). One of these is in
the British Museum, inscribed in pencil 'printed by F.
Seymour Haden' (1899-7-13-54), and shows the pro-
minent streak of lightning which was not part of
Turner's original design, as can be seen from this late
engraver's proof; the lighting may, perhaps, have been
added by Seymour Haden who may have also re-
touched the plate for 'Catania' (see cat.no.53).

According to Rawlinson (1908-13, II, p.387), the
plate for 'Ship in a Storm' was purchased from the
Turner sale by Messrs Colnaghi who subsequently took
a number of (apparently rather poor) impressions from
it (the supplier's name G. Harris of no. 31 Shoe Lane,
London, is engraved on the verso; Harris also supplied
Turner's copper plates, see under cat.no.38). In 1942
Colnaghi's donated the plate to the British Museum
(1942-8-10-2), together with that for the mezzotint
'Ship and Cutter' (R.808), the only other steel plate
from the series to have survived in good condition
(1942-8-10-3).

53 **Catania, Sicily** *c.*1826
for the 'Little Liber'
Mezzotint on copper printed in black ink, late
nineteenth-century impression on india paper
(R.805): 153 × 215; 332 × 404; 191 × 255
T05568

Turner's watercolour for this subject is in the Boston
Museum of Fine Arts (W.774), and was for many years
thought to show a view of St Peter's in Rome in a
thunderstorm. The subject was later identified as the
church of S. Nicolò in Catania and the model for this
print which, unlike the watercolour, includes on the far
left horizon the distant outline of Mount Etna, emitting
a trail of smoke. Since Turner never visited Sicily, he
must have relied for this composition on a sketch by
another artist.

The outline of Etna, only added by Turner in a late
engraver's proof, is defined more sharply in Seymour
Haden's impression taken before the Turner sale in
1873 which also shows the light ripples over the sea (one
is in the British Museum, 1899-7-13-52). This im-
pression, however, shows the further retouchings which
were made after the plate was acquired by Colnaghi's,
purchased by them at the Turner sale (see Rawlinson,
1908-13, II, p.388).

An interesting touched proof, in which the felucca to
the left and other details were pencilled in by Turner, is
in the Yale Center for British Art (repr. Wilton,
1980-81, p.160).

54 **Gloucester Cathedral** *c.*1826
Watercolour and pencil
230 × 302
Turner Bequest; CCLXIII 307
D25430

Another colour study of this subject is in the Turner Bequest (TB CCLXIII 246, repr. Wilkinson, 1975, p.119). It was, however, this version which Turner used for the mezzotint in the 'Little Liber' series (cat.no.55).

55 **Gloucester Cathedral** *c.*1826
for the 'Little Liber'
Mezzotint on copper printed in black ink, late nineteenth-century impression on india paper
(R.809): 150 × 213; 333 × 406; 188 × 253
T05571

This print continues to be known by its traditional title, 'Gloucester Cathedral', although its subject has never been firmly identified; Wilkinson, for example, sugges-

ted (1975, p.119) that it might rather show the spire of a parish church somewhere in the Midlands. It is less commonly referred to by either of its two alternative titles, the 'Boston Stump' or 'The Hare' – a name which arises from the prominent creature which Turner added to the foreground at a later stage in the evolution of the print, together with a selection of grasses, mushrooms and burdock leaves.

The copper plate for this print was retouched at some stage before the Turner sale (Rawlinson, 1908–13, II, p.390), as impressions taken by Seymour Haden at that time testify (one is in the British Museum, 1899-7-13-51). This impression, however, like that of 'Catania' (cat.no.53) also printed on india paper, dates from later in the century.

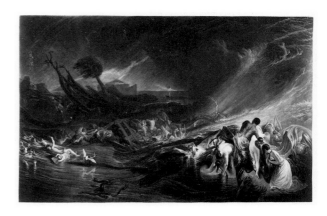

J.B. QUILLEY (fl. 1812–42) AFTER
J.M.W. TURNER

56 **The Deluge** 1828
Mezzotint printed in black ink, engraver's proof b)
(R.794): 380 × 577; 588 × 872; 460 × 630
T04838

Not a single mezzotint is known to have been made after Turner's work between 1830 and 1851, the year of the artist's death. The 'Little Liber' subjects were the last mezzotints to be scraped by Turner himself, and *The Ports of England* was the last series in which his drawings were translated into mezzotint by other engravers. Before finally abandoning the process, however, in the late 1820s Turner supervised the production of a number of larger-scale mezzotints after his oils, chiefly subjects which he had painted much earlier in his career (see R.791-7); this print, for example, reproduces 'The Deluge' which was painted *c.*1805 (B&J 55; Gallery 107).

In their dark tonality many of Turner's early pictures lent themselves particularly well to translation into

mezzotint, especially a subject like 'The Deluge' with its 'thicken'd sky like a dark ceiling'. These lines from Milton's *Paradise Lost* were quoted by Turner in the catalogue when he exhibited the painting at the Royal Academy in 1813. It has been suggested (Wilton, 1980-81, p.139) that Turner's wish to bring 'The Deluge' to the public's attention again fifteen years later by publishing it in the form of a mezzotint may have been prompted by increasing competition from two younger painters who specialized in similar apocalyptic canvases, John Martin and Francis Danby (although given the picture's indebtedness to Poussin, another factor might have been the revival of interest in that French painter's work following the publication in 1822 of his first English biography, written by Maria Graham). For although Martin had launched himself as a painter of the sublime some years earlier, it was in 1826 that he produced his first version of a deluge subject (whereabouts unknown; the painting was, however, published by Martin in 1828 as a mezzotint, repr. W. Feaver, *The Art of John Martin*, 1975, p.93); and Danby exhibited his first biblical canvas at the Royal Academy in 1825, the 'Delivery of Israel out of Egypt' (Harris Museum and Art Gallery, Preston, repr. Greenacre, *op.cit.*, p.97). Indeed, Quilley's mezzotint after Turner's 'Deluge' includes a number of rather macabre details which are absent from the original picture, and which suggest that Turner may indeed have been responding to the sensationalist canvases of these two rivals. The barest indication of a snake in the water in the foreground of the oil has been transformed in the print into a group of intertwined and writhing serpents; whilst the mezzotint also includes a pair of outstretched hands protruding just above the surface of the water to the left, indicating the futile struggle of a panic-stricken victim who has already been engulfed by the merciless waves.

Both these details were pencilled in by Turner in an early engraver's proof of this mezzotint in the British Museum (1893-6-12-172). Another, later engraver's proof in the British Museum (1893-6-12-173) shows the ark on the right-hand side rather than the left, indicating that Quilley seems to have had difficulty interpreting the original painting. The published state of the print with letters includes a dedication by Turner 'To the Right Honorable (the late) Earl of Carysfort, K.P.', suggesting that the painting may originally have been comissioned for him, although it never left Turner's studio.

THE ANNUALS (cat.nos.57–60)

For more than a decade, after 1826, much of Turner's work for the engravers was concerned with the production of designs for small annuals such *The Keepsake*, *The Literary Souvenir* or *The Amulet*. These editions of 'pocket' literature were very much in vogue at this time and were usually anthologies of sentimental prose and poetry, much of it inspired by the engraved illustrations. Their popularity was largely thanks to Charles Heath who in 1826 had turned his attention from engraving to promoting and publishing such literature; he was responsible for some of the best known of the annuals, including *The Keepsake*. Heath was well aware that Turner's talent and fame would ensure a wider market for his decorative and topographical publications; this fruitful association between artist and publisher reached it peak of achievement in the series *Picturesque Views in England and Wales* (cat.nos.19–23).

EDWARD FINDEN (1791–1857) AFTER J.M.W. TURNER

57 **Steel Plate for 'Bolton Abbey'** *c.*1826
115 × 167
Iain Bain

The introduction of steel plates had occurred around 1820 and Turner pioneered its use for mezzotints in his series of *The Rivers of England* (cat.no.42), commenced in 1823. However, he waited a few years until the technique had been developed before using it for line-engraving.

'Bolton Abbey', engraved for *The Literary Souvenir*, was one of the first line-engravings after a design by Turner to be executed on steel. The main advantage of

steel plates was the fact that they were much harder than copper, and therefore wore down less quickly, thus producing far more impressions from each plate. The introduction of steel was at first opposed by the engravers as it greatly increased their manual labour and wore out their tools; a plate this size, for instance, could take as long as thirteen weeks to prepare. To ease their work, the engravers etched with acid a large part of the plate; for delicate lines in particular (such as in the sky and distance), it was easier to use the etcher's fine needle to scrape through the soft etching ground than a burin through steel. A typical steel engraving, therefore, will in fact consist almost entirely of etched lines laid in the regular manner of an engraving. Steel-plate engravings usually have a very different character from those on copper plates; extremely fine lines, often closely massed in parallel, were dictated by the hardness of the metal. This was very different from the broad, open and deep lines produced from copper plates, although some of the strong lines (for instance, those needed for the foreground trees in this plate) would be heavily gouged with a burin (see cat.no.58). The delicacy of the prints produced from steel plates made them particularly suitable for small, intricate designs such as book illustrations.

artist and engraver and *Printed for Hurst, Robinson, & Co. London, 1826* and *Printed by MᶜQueen.*
Iain Bain

The Literary Souvenir is described on the frontispiece as a 'Cabinet of Poetry and Romance' and contains a variety of poetry and short stories. In his preface, the editor, Alaric Watts, is keen to expound the virtues of the publication and proudly describes the engraved illustrations as being 'in a style which . . . has certainly never been surpassed, if equalled, on the small scale to which they are necessarily restricted' and particularly points out this 'splendid' view of 'Bolton Abbey'.

The original watercolour for this plate (British Museum; w.532) was executed in 1809, supporting the suggestion that the publishers were happy enough to accept existing drawings if relevant rather than always commissioning new ones (but see cat.no.60).

R. WALLIS AFTER J.M.W. TURNER

59 **Virginia Water, No.1** 1830
for *The Keepsake*
Engraving, india proof (R.322): 93 × 139;
265 × 330; 152 × 216
Engraved inscriptions: below, with engraver's name
T04616

Turner made studies of Virginia Water in the *Kenilworth* sketchbook (TB CCXXXVIII) of 1829 from which two finished watercolours were developed; the watercolour on which this engraving was based (w.520) and its pair, (w.519), also engraved for *The Keepsake* (as R.323). The preliminary watercolour designs for the annuals were usually much larger than their engraved versions; the watercolour for this engraving, for example, was three times its size.

58 **The Literary Souvenir**
London, 1826
Open at p.313: 'Bolton Abbey, Wharfdale'
Engraving by E. Finden after Turner, later state on india paper (R.315): 74 × 103; 126 × 198; 112 × 162
Engraved inscriptions: below, with title, names of

Although this is an attractive view, showing the Chinese Pavilion and swans in the foreground, the composition is rather too tightly compressed into its rectangular format, whose clearly defined border seems particularly restricting on such a small scale. It was no doubt his awareness of this problem that subsequently prompted Turner to concentrate on the vignette form which allowed the design to fade gradually into the white of the paper.

J.T. Willmore after J.M.W. Turner

60 **Burning of the Houses of Parliament** 1835
for *The Keepsake*
Engraving, first published state on india paper
(R.332): vignette, 115 × 90; 435 × 285; 220 × 152
Engraved inscriptions: below, with names of artist and engraver; bottom, 'LONDON, PUBLISHED OCT.ʳ 1835, FOR THE PROPRIETOR, BY C. TILT, FLEET STREET.'
T04628

It is possible that Heath and Turner maintained a fairly flexible arrangement as to where the artist's drawings made for engraving would ultimately appear. Some of the illustrations for *The Keepsake* were possibly originally intended for use in other projects on which Turner was engaged at that time or were recycled from schemes abandoned by artist or publisher. This vignette, however, may have been one that was specifically intended for the work since it portrays a momentous contempor-

ary event, likely to have appealed to a popular audience. The burning of the Houses of Parliament in 1834 was the subject of numerous watercolours as well as two oils by Turner (B&J 364 and 359). Many views like this one are seen from the river, Turner having sketched the event from a boat (see Cleveland Museum of Art, exhibition catalogue, 1984).

ILLUSTRATIONS TO SAMUEL ROGERS (cat.nos.61–70)

The success of Turner's engravings for the annuals, following the advent of the use of steel plates, encouraged the publication of large illustrated editions of works by popular authors. Samuel Rogers, the wealthy banker, connoisseur and poet, was the first to use Turner's talents to illustrate his own work, firstly for *Italy* in 1830 and then for his *Poems* in 1834.

Rogers's long poem *Italy*, a sequence of short verses recording his experiences during a tour of Italy from 1814 to 1815, had been published in two parts; the first, anonymously, in 1822 and 1824, the second in 1828. Neither were attended with any success and before the second part was issued, Rogers had decided to reissue a new 'edition de luxe' at his own expense. In 1826, he invited Turner to design twenty-five vignette illustrations, hoping that the artist's fame would enhance the popularity of his work. He was certainly correct in his assumption, for *Italy* became such a success on its publication in 1830, that it was observed 'Of Rogers's *Italy*, Luttrell relates, Twould surely be dished if twernt for the Plates' (Powell, 1983). Another popular artist, Thomas Stothard, was also employed, executing the figure scenes, while Turner was responsible for the landscape subjects.

Turner was to be paid the large sum of £50 for each drawing but as this fee threatened to impose too great a financial burden on the project, the watercolours were instead loaned by Turner at five guineas each and returned to him after the engraving was complete. The same system was followed with the illustrations by Turner for Rogers's *Poems* and as a result, all except one of his illustrations to Rogers have survived in the Turner Bequest (see cat.no.61). In dealing with a sympathetic spirit like Rogers, Turner thus showed himself to be amenable, indeed generous, and their association stood in contrast to the apparently fraught relationships that emerged between Turner and other authors, publishers or engravers (for instance the Cookes and Charles Turner). Consequently, the collaboration with Rogers

continued with the publication of the *Poems* in 1834, which reprinted nearly all of Rogers's works other than *Italy*, including the long poem which had made his reputation, 'The Pleasures of Memory'. The *Poems*, like *Italy*, had been published earlier in 1827 and had received little praise but the new edition of 1834, containing thirty-three engravings after designs by Turner, proved so popular that it was further reissued in 1836, in ten monthly parts.

The popularity of the Rogers' volumes was beneficial to poet, artist and engraver. The fifty-eight designs by Turner for *Italy* and the *Poems* immortalised the poetry of Rogers and, in turn, the volumes were important agents in spreading Turner's reputation. By 1847, over 50,000 copies of the two volumes had been sold and they were amongst the most successful illustrated books of the nineteenth century.

Rogers's Italian tour from 1814 to 1815 was the inspiration for the poem. Turner, for his illustrations, had recourse to his own direct experience of continental scenery during his tours to the Alps in 1802 and to Italy in 1819; material collected on a subsequent journey to Italy in 1828 would almost certainly have been too late to be incorporated in the designs. The routes that Rogers and Turner took through Italy differed but had often coincided; Turner had visited the Hospice shown here on his tour of 1802, making sketches in the *Grenoble* sketchbook (TB LXXIV 55, 61) while Rogers, in his poem, was commemorating the place where he crossed into Italy and the Hospice where he was welcomed.

The original watercolour for this engraved vignette is the only one not in the Turner Bequest; it was acquired by John Dillon and shortly after became one of the first watercolours by Turner to enter a collection in the U.S.A. (W.1156). Pencil sketches of dogs and a figure on a stretcher appear in the margins on this watercolour. Objections had apparently been made to Turner's drawing of the St. Bernard dogs, as a result of which models for the engraver were drawn by the successful animal painter, Edwin Landseer. Likewise, the figure was reworked in the margin by Stothard, Turner's collaborator on the *Italy* illustrations. Ruskin suggested that the 'improvements' to Turner's dogs and figures were not followed by the engraver since Rogers preferred the originals (*Works*, XIII, p.514). However, it is evident that Landseer's dogs were in fact copied by Smith, although Stothard's figure seems to have been rejected. There were other occasions when Turner seems to have left a fellow artist, such as Stothard, or the engraver, to complete the animals or figures for him (*Reminiscences*, 1902, pp.59–60); the chamois in 'The Alps at Daybreak' (R.395) were supposedly drawn by the engraver, Edward Goodall (see also cat.nos.65 and 67).

WILLIAM R. SMITH (fl.1820s to 1850s)
AFTER J.M.W. TURNER

61 **Hospice of the Great St. Bernard. II. (The Dead-House)** 1829
for Rogers's *Italy*, p.16
Engraving, third published state (R.352): vignette,
85 × 84; 379 × 278; 257 × 140
Engraved inscriptions: below, with title, names of artist and engraver and *Triggs Printers*; bottom,
London, Published September 1, 1829 by R. Jennings, 62 Cheapside
T04638

R. Wallis after J.M.W. Turner

62 Banditti 1830
for Rogers's *Italy*, p.183
Engraving, second published state on india paper
(R.367): vignette, 96 × 85; 440 × 306; 260 × 143
Engraved inscriptions: below, with title, names of
artist and engraver and *Triggs Printer*; bottom,
*London. Published January 1, 1830 by Robert Jennings
and William Chaplin, 62 Cheapside*
T04661

Since the vignette engravings were printed on the same
page as the text, they had to be small, but Turner has
nevertheless managed to capture remarkably spacious
effects in these designs; this view of rugged mountain
scenery, for instance, retains its grandeur and has a
feeling both of the distant mountains and the depth of
the ravine. The sense of scale in the Rogers' illustrations
is enhanced by the adoption of the vignette form which
could be altered to suit the subject (such as an elongated
vertical shape in this design) and whose edges blended
into the white of the paper, expanding the whole image
outwards into an indefinite radiance.

Several of the original watercolour designs were
altered so that their compactness would be maintained
once they were engraved; the watercolour for 'Banditti'
(TB CCLXXX 164) had three figures in the extreme left
foreground, omitted in this print since their presence
would have shifted the focal point of the design away
from the centre. The composition of the vignettes, with
their concentration on the centre, was one that Turner
was also to experiment with in some of his later oil
paintings such as 'Light and Colour' and 'Shade and
Darkness' (B&J 405 & 404, both in Gallery 101).

63 Paestum *c.*1827
Pencil and watercolour
240 × 305
Turner Bequest; CCLXXX 148
D27665

The watercolours that Turner executed for the Rogers'
illustrations are surprisingly loosely handled consider-
ing that the engraved translations of them are filled with
intricate detail. It is possible that Turner saw these
drawings merely as guides for the engravers in the
preliminary stages of their work and found it easier to
work up the details of the image on the engraver's
proofs, by adding pencil sketches or annotations (see
cat.no.4). Turner's revisions are certainly not confined
to simply making the engravings closer reproductions of
the watercolours but are concerned with the need for
the engravings to be effective in their own right.

In this watercolour, for instance, the lightning is
barely discernible whereas in the engraving (cat.no.64)
three strong flashes of lightning have been included and
are set against a blacker sky. It is interesting that in
Turner's mezzotint of 'Paestum' for the 'Little Liber'
(see under cat.no.48), there are also forks of lightning
which do not appear in the original watercolour
although, in that instance, it is more understandable
that the watercolour is lacking in specific detail since
Turner was himself the engraver.

JOHN PYE AFTER J.M.W. TURNER

64 **Paestum** 1830
for Rogers's *Italy*, p.207
Engraving, third published state (R.369): vignette,
60 × 86; 380 × 278; 253 × 144
Engraved inscriptions: below, with names of artist
and engraver and *Temples of Paestum* and *Triggs
Printer*; bottom, *London. Published January 1, 1830 by
Robert Jennings &c. William Chaplin, 62 Cheapside*
T04665

Rogers took a keen interest in the progress of the illustrations for his book and his comments on Turner's designs are recorded in an annotated copy of *Italy* in the Victoria and Albert Museum (National Art Library).

The canto to which this engraving was an accompaniment describes the bleakness of the site; 'They stand between the mountains and the sea;/ Awful memorials but of whom we know not! ...' Although Rogers's verse was not a great literary achievement, the lavish 1830 volume of *Italy* brought Turner's work to a wide public. Ruskin was presented with a copy for his thirteenth birthday and later claimed: 'This book was the first means I had of looking carefully at Turner's work; and I might, not without some appearance of reason, attribute to the gift, the entire direction of my life's energies' (*Works*, XXV, p.15).

E. GOODALL AFTER J.M.W. TURNER

65 **Traitor's Gate, Tower of London** 1834
for Rogers's *Poems*, p.88
Engraving, third published state (R.383): vignette,
84 × 82; 377 × 281; 292 × 152
Engraved inscriptions: below, with title, names of
artist and engraver and 'Printed by *Gad &
Keningale*'; bottom, 'London. Published 1833, by
Moon, Boys & Graves, 6 Pall Mall.'
T05116

Well over half of the illustrations for Rogers were executed by Goodall who, along with the other engravers, was paid between £30 and £40 per plate; although less than Turner was offered for his watercolours, this was quite a generous sum. According to Rawlinson (1908–13, I, p.lii), Goodall's son recalls '[taking] his father's trial proofs backwards and forwards to Turner for his criticism and that not unfrequently, the painter left the engraver to put in the figures. His father kept in his studio for that purpose, casts of both the human body and of animals'. In this illustration to the poem 'Human Life', it is therefore possible that Goodall may have drawn in the figures of the prisoner, axeman and warders himself; alternatively, this may be another example of Stothard's help (see cat.no.61).

E. GOODALL AFTER J.M.W. TURNER

66 St Anne's Hill. II 1833
for Rogers's *Poems*, p.214
Engraving, third published state (R.397): vignette,
78 × 80; 380 × 282; 292 × 151
Engraved inscriptions: below, with title, names of
artist and engraver and *Gaywood &c.Co. Printers*;
bottom, 'LONDON, PUBLISHED 1833 BY MOON,
BOYS & GRAVES, PALL MALL.'
T05123

Turner produced two views of St Anne's Hill, the
Surrey home of the radical statesman, Charles James
Fox; a view of the house (R.384) and this one of the
garden, which was published as the tail-piece to the
poem, 'Written in Westminster Abbey', that had been
prompted by Fox's funeral in 1806.

Turner seems to have had great respect for Rogers's
criticisms of his illustrations for on a touched proof of
this plate (Rawlinson, 1908–13, II, p.245) he wrote,
'Mr. Rogers brought me this wishing it to be made
richer of flowers' and, accordingly, drew more roses on
the trellis. It was perhaps the charm of illustrations such
as this that led Ruskin to describe them as 'the loveliest
engravings ever produced by pure line' (*Works*, XIII,
p.380).

67 Land Discovered by Columbus* *c.*1832
Pencil and watercolour
198 × 297
Turner Bequest; CCLXXX 190
D27707

Of all the illustrations for Rogers, those for the poem
'The Voyage of Columbus' display Turner's imagin-
ation at its most fertile. This watercolour, later en-
graved as the head-piece to Canto VIII (cat.no.68)
juxtaposes the ocean's vastness with the isolated figure
of Columbus.

On the left of the watercolour, Turner has added
pencil sketches to clarify his intentions to the engraver.
Alterations have been made to the shape of the large
ship with variations to the details of the bow, clearly
showing four oar-ports; the boat behind has also been
changed. These variations have been closely followed in
the final engraving. The loose handling of the water-
colour, lacking any detailed definition, shows how
difficult Turner's ideas must have been for the en-
gravers to interpret even with the help of such ad-
ditional sketches (see also cat.no.63). The figure of
Columbus, for instance, is shown here looking towards
the viewer but has been changed in the engraving into a
far more imposing figure, in a very different costume,
looking out to sea; it may be that this figure was another
of Goodall's own (see cat.no.65). An inscription in
Rogers's own copy of *Italy* (see cat.no.64), although
equally applicable to the *Poems*, states that the 'draw-
ings [were] returned to him [Turner], after they had
been engraved, and the truth is, they were of little value
as drawings. The engravers understood Turner perfect-
ly and make out his slight sketches'. Turner's water-
colour illustrations, especially those for Rogers, are
often considered to be poorly adapted to the require-
ments of the engravers, not only in their lack of detail
but in their vibrant use of colour which must have
confused the engravers. The fact that Turner made few
concessions to the engravers was perhaps due to his

desire that the watercolours should still be works of art in their own right; to adapt the watercolours to the engravers' requirements would have meant Turner completely altering his style. His decision to do justice to both media was, therefore, the only practical course open to him. It was the idiosyncratic and unnaturalistic use of colour that Turner adopted for small illustrations which has led to criticism of them (see Rawlinson, 1908–13, I, p.li), although the engraved vignettes were greatly admired.

However, in the engraved version of this illustration (cat.no.68), Goodall has managed to interpret the pencil sketches and the use of colour, whose tonal values have been closely followed, with consummate skill.

by the engraver with the exquisite precision of a miniaturist but without any loss of the softness and gentleness of modulation apparent in the watercolours, on which the subtlety of the atmospheric effects rely.

Painstaking and skilful craftmanship was needed to create these beautiful, jewel-like engravings. The etching required great care in case the acid penetrated areas outside the minute lines and considerable skill was needed with the burin since faults were very difficult to correct in such delicate work. Although the steel was harder to engrave (see cat.no.57), it is doubtful if the ethereal quality could have been obtained if copper had been used since the lines soon loose their crisp edges and could not withstand retouching as steel could.

E. Goodall after J.M.W. Turner

68 Land Discovered by Columbus* 1834
for Rogers's *Poems*, p.248
Engraving, first published state on india paper
(R.401): vignette, 86 × 80; 432 × 300; 292 × 150
Engraved inscriptions: below, with title, names of artist and engraver
T05127

The illustrations to Rogers are often cited as being the finest and most important of Turner's book illustrations and whether or not this can be decided, such a tribute is understandable and must be due not only to Turner's vivid imagination but also to the skills of his engravers. The mass of detail in many of the vignettes is rendered

69 Turner's Copy of Rogers's *Poems*
London, 1827
Open at pp.184–5
187 × 255
Turner Bequest; CCCLXVI 184,5
D36330

Turner used this copy of the 1827 edition of Rogers's *Poems* when preparing his proposals for his illustrations. The edition was illustrated with woodcuts by Luke Clennell, after designs by Stothard, of classically clad maidens and putti and associated decorative motifs. These serve as embellishments rather than illustrations and were used to fill up the blank spaces; they bear no relation to the text.

Turner, on the other hand, proceeded directly from

the poetry. This volume is filled with his slight sketches for proposed illustrations, some of which are very close to his final treatment. However, in the case of 'Captivity', for which his ideas are exhibited here, Turner was obviously first inspired by the opening lines '. . . when the hern screams across the distant lake. . .' but in the final version chose to illustrate the captive imprisoned in the castle (see cat.no.70).

70 **Rogers's *Poems***
London, 1834
Open at pp.172–3: 'Captivity' (R.390)
198 × 260
Lib. 07668

This is the 1834 published edition of the *Poems* showing Turner's illustration to the poem 'Captivity'. By comparison with the earlier edition (see cat.no.69), it is easy to see how Turner's illustrations, closely tied to the text, enabled the book to become such a great success. No doubt Rogers was delighted with the warm response to both *Italy* and the *Poems*, although it may well have been disappointing for him to know that the readers were far more impressed by the illustrations than by his poetry.

ILLUSTRATIONS TO SIR WALTER SCOTT (cat.nos.71–77)

The success of the Rogers volumes encouraged other authors and publishers to seek to increase their market with the help of Turner's illustrations and throughout the 1830s, Turner received a series of commissions for small-scale illustrations to literature.

In 1831, Turner was commissioned by the Edinburgh publisher, Robert Cadell, to illustrate a series of books incorporating the works of Sir Walter Scott. The author had gone bankrupt in 1826 and Cadell insisted that Turner illustrate the proposed edition of Scott's *Poetical Works* claiming, in a letter to the author, of 28 March, 1831, 'With his pencil, I shall insure the subscription of 8,000, without, not 3,000' (National Library of Scotland MS 3917, fol.142).

Scott was at first reluctant to employ Turner, having met with difficulties with the artist during their first collaboration on *The Provincial Antiquities of Scotland*, published between 1819 and 1826; then he had commented that 'Turner's palm is as itchy as his fingers are ingenious and he will . . . do nothing without cash and anything for it' (see Finberg, 1961, p.257). The project had been a financial disaster but Scott must have appreciated Turner's illustrations for he kept eight of them mounted together in his breakfast room at Abbotsford.

Despite this unhappy earlier collaboration, Cadell was delighted to secure Turner's services to illustrate Scott's *Poetical Works* – the first part of the scheme to publish all Scott's writings in verse and prose – especially since 'His terms are fully under what I expected; 24 designs at 25 gns. each' (Cadell Papers. MS 3917, 160, National Library of Scotland). Twelve volumes of the *Poetical Works* were planned, each with a frontispiece and title-page vignette. Cadell's optimism proved fully justified and the *Poetical Works* became extremely popular on their publication in 1834. Unfortunately, Scott died on 21 September 1832, so failed to see the great success of this illustrated edition.

Turner had already started work on forty designs to illustrate the complete *Prose Works* by the time of Scott's death and twenty-eight volumes were published between 1834 and 1836. Since these included the *Life of Napoleon* and *Tales of a Grandfather*, the illustrations covered a wider range of subject-matter and were not limited to landscape views of Scottish scenery as in the *Poetical Works*. Cadell also planned an illustrated edition of the *Life of Sir Walter Scott* written by Scott's son-in-law, John Gibson Lockhart. In the event, only three illustrations by Turner, of places where Scott had lived, appeared in the second edition of 1839.

In addition to the lengthy Cadell commissions, Turner also produced six designs for Fisher's *Illustrations to Waverley Novels*, published between 1836 and 1837.

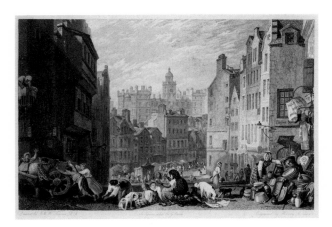

HENRY LE KEUX (1787–1868) AFTER
J.M.W. TURNER

71 **Heriot's Hospital, Edinburgh** 1822
for *Provincial Antiquities of Scotland*, vol. II, p.97
Engraving, india proof b), (R.195): 164 × 244;
328 × 436; 256 × 331
Engraved inscriptions: below, with names of artist
and engraver and 'the Figures etched by G. Cooke'
and 'Herriott's Hospital.'
T04492

In 1818, Turner received a commission for a series of
plates showing Scottish locations which were to be
accompanied by a text by Scott. The engravings were to
be issued in a set of ten paper-bound parts, and
subsequently in two volumes, containing ten subjects
plus two title-page vignettes by Turner as well as
illustrations by other artists such as A.W. Callcott,
Edward Blore and Scott's friend, the amateur land-
scape painter, the Rev. John Thomson of Duddingston.

Turner made a special journey to Scotland in 1818 to
collect material for the work, sketching mostly in
Edinburgh with brief excursions into the surrounding
countryside. Since Turner was only there for two weeks,
he did not necessarily make Scott's acquaintance on this
occasion. A second trip of 1822, when Turner followed
George IV's tour of Scotland, provided further
material.

This engraving, originally entitled 'Grassmarket,
Edinburgh', is typical of the series, having a somewhat
antiquarian feel, perhaps due to its crowded compo-
sition and rather awkward figures, but also as a result of
its being engraved on copper in a rather archaic way;
the lines lack the delicacy and fine tonal gradations so
apparent in the later Scott engravings executed on steel
(cat.nos.72, 74–76).

E. GOODALL AFTER J.M.W. TURNER

72 **Johnnie Armstrong's Tower** 1833
for Scott's *Poetical Works* ('Minstrelsey', vignette
title, vol. II)
Engraving, first published state on india paper
(R.496): vignette, 104 × 86; 437 × 291; 209 × 151
Engraved inscriptions: below, with title, names of
artist and engraver and *B. late Dixon*; bottom,
*Edinburgh 1833, R. Cadell, London, Moon, Boys &
Graves*
T05136

Throughout 1830, Scott and Cadell corresponded with
Turner to advise him on the choice of subjects for the
Poetical Works, and in 1831 Turner visited Scotland to
sketch the twenty-four sites they had selected. Turner
was invited to stay at Scott's home, Abbotsford, but
made some of his sketches, such as those of 'Johnnie
Armstrong's Tower', before his arrival there. Others
were executed in the company of Scott and Cadell at
Abbotsford and Turner completed his tour by travel-
ling as far as Staffa and Inverness. Several sketchbooks
were filled on this tour, providing material not only for
the Scott engravings, but for other watercolours and
paintings as well. This engraving was published as the
title vignette to volume two of *Minstrelsy of the Scottish
Border* and depicts the tower of the notorious sixteenth-
century Border raider, Johnnie Armstrong, Laird of
Gilnockie. Like all the vignettes, it was designed with a
decorative cartouche surround, consisting of a simple
line frame ornamented with figures; these borders were
not used in the published editions save in one design of
'Abbotsford' (R.516).

73 **Dryburgh Abbey** *c.*1832
Watercolour
79 × 149
N05241

Dryburgh Abbey was one of the many interesting spots
in the countryside around the Border chosen for Turner
to draw while staying at Abbotsford. Turner and Cadell
made a day-trip to the Abbey from Scott's home and the
artist made several sketches in the *Abbotsford* sketchbook
(TB CCLXVII), including both closer views of the Abbey
and this panorama of the ruin within a loop of the River
Tweed. Cadell greatly admired Turner's work, com-
menting, 'There is about Turner's pencil . . . that which
renders familiar scenes more striking and lovely than
before' (letter to Scott, 31 March 1831, cited above).

Twelve of the watercolours for the *Poetical Works* were
exhibited at Messrs. Moon, Boys and Graves in Pall
Mall in 1832, in order to advertise the forthcoming
publication. They were well received and regarded as
being 'unequalled for beauty' (quoted Finberg, 1961,
p.334).

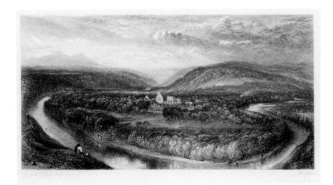

WILLIAM MILLER (1796–1882) AFTER
J.M.W. TURNER

74 **Dryburgh Abbey** 1833
for Scott's *Poetical Works* ('Sir Tristram',
frontispiece, vol. v)

Engraving, first published state on india paper
(R.501): 80 × 148; 279 × 433; 150 × 207
Engraved inscriptions: below, with title, names of
artist and engraver; bottom, *Edinburgh 1833, R.
Cadell &c. Moon, Boys & Graves, London*
T05141

Having sketched the relevant sites for this project,
Turner returned to London in September 1831 and
worked on the watercolours during the following year
(see cat.no.73). The drawings were engraved by many
of those who had worked for him before, such as
William Miller, considered by Ruskin to be the best of
Turner's engravers (see Omer, 1975). Their task con-
tinued until 1834 when the work appeared; 'Dryburgh
Abbey' was published in volume five, as the frontispiece
for *Sir Tristram*.

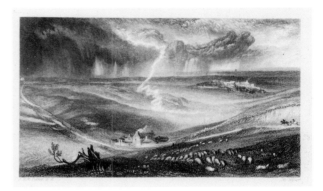

W. MILLER AFTER J.M.W. TURNER

75 **Field of Waterloo (with Lightning)** 1835
for Scott's *Prose Works* ('Life of Napoleon')
Engraving, first published state on india paper
(R.539): 84 × 142; 300 × 434; 152 × 208
Engraved inscriptions: below, with names of artist
and engraver; bottom, 'LONDON, PUBLISHED
1835 BY ROBERT CADELL, &C. HODGSON, BOYS
& GRAVES, LONDON.'
T04747

The illustrations for the *Prose Works* covered a wide
range of subject-matter and although, like the *Poetical
Works*, they were basically topographical views, they
served as backdrops against which the dramas de-
scribed in Scott's writings such as those in the *Life of
Napoleon* were enacted. Many of the illustrations for the
Life of Napoleon necessitated Turner's visiting places
which were associated with the life of the former
Emperor and he collected much material during his
French tour in 1832 while he was collecting subjects for
the 'Rivers of France' series (see cat.no.27). However,

some of the illustrations for the *Life of Napoleon*, including this one, were developed from earlier sketches. In 1817, Turner had executed a watercolour of the 'Field of Waterloo' showing it on the day of the battle (w.494), and the following year he painted the oil (b&j 138; Gallery 107) which shares the same dramatic mood; the painting was engraved as a large mezzotint in 1830 (r.795). This view, however, is of the open plain as seen many years after the battle: the subject has clearly continued to spark Turner's imagination.

Nevertheless, many of the illustrations were based on earlier material. The Rhymer's Glen, in the grounds of Abbotsford, for instance, had orginally been proposed as a subject for the *Poetical Works* and was sketched by Turner on his tour of 1831, when he was accompanied by Scott's two daughters. Another subject, 'Chiefswood Cottage', the Lockharts' home, was also drawn on this earlier visit and both designs were used to illustrate volumes of the *Prose Works* containing Scott's 'Periodical Criticism'.

This illustration, engraved as the title vignette for volume twenty-one, depicts a rustic seat, open book and walking stick, thereby alluding symbolically to Scott's presence in one of his favourite spots on the Abbotsford estate; it is perhaps Turner's personal tribute to the great writer.

W. MILLER AFTER J.M.W. TURNER

76 **The Rhymer's Glen** 1835
for Scott's *Prose Works* ('Periodical Criticism', vol.xxi)
Engraving, first published state on india paper (r.542): vignette, 122 × 82; 435 × 300; 208 × 150
Engraved inscriptions: below, with names of artist and engraver; bottom, 'EDINBURGH. PUBLISHED 1835 BY ROBERT CADELL, &c. HODGSON, BOYS & GRAVES, LONDON.'
T04749

Since Turner had made several tours of Scotland prior to working on the *Prose Works*, filling several sketchbooks, he was reluctant to plan a special trip as he felt he already had sufficient material for the illustrations. However, he was persuaded by Cadell to make a further tour of Scotland in 1834 to obtain material for the *Prose Works* as well as the proposed *Life of Sir Walter Scott*.

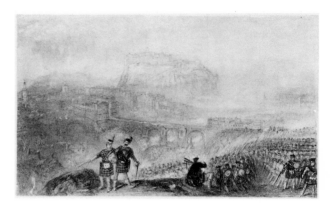

77 **March of the Highlanders** *c.*1835
Watercolour
86 × 140
N04953

Turner produced six designs for Fisher's *Illustrations to the Waverley Novels* which appeared in 1836 and 1837. The illustration of these novels was originally projected by Cadell, whose apparent unwillingness to proceed with the commission led Turner to accept Fisher's instead. This illustration to *Waverley* was based on sketches made during earlier tours of Scotland, particularly those of 1801 and 1822; it shows a panoramic view of Edinburgh from Calton Hill with a crowd of Highlanders mustering in the foreground. It is typical of the type of composition that Turner produced for Scott; although confined to a tiny space, he has created one of his most expansive and densely populated views. Scott had complained of Turner's penchant for depicting 'highlanders in every Scottish scene', indicative of the fact that Scott and Turner had little in common in their conception of the purpose of the illustrations.

78 **Rievaulx Abbey** *c.*1835
Watercolour
122 × 207
N05615

This watercolour was engraved for *The Gallery of Modern British Artists* in 1836 (see cat.no.79). However, it may have been originally intended as an illustration to Scott since the watercolour would have been executed around the same time as those for the Scott commission and with which it has certain stylistic similarities (see in particular, 'Dryburgh Abbey', cat.no.73).

JOSEPH CLAYTON BENTLEY (1809–1851)
AFTER J.M.W. TURNER

79 **Rievaulx Abbey** 1836
for *The Gallery of Modern British Artists*
Engraving, engraver's proof (R.571): 93 × 155;
277 × 383; 229 × 276
T05151

Two prints of Rievaulx had already been engraved after Turner's designs by this date; one for *Picturesque Views in England and Wales* (R.209) and another for the *Liber Studiorum* (R.L.51). This watercolour is similar in viewpoint to the *England and Wales* design but the Abbey ruins are less well defined while the surrounding landscape and country people have captured most of Turner's interest.

E. FINDEN AFTER J.M.W. TURNER

80 **Jerusalem, Pool of Bethesda** 1836
for Finden's *Landscape Illustrations of the Bible*
Engraving, india proof (R.591): 96 × 142;
303 × 441; 226 × 276
T05172

Throughout the 1830s, Turner's commissions as an illustrator had been for works of poetry and literature by popular, usually contemporary authors such as Rogers or Scott. These tended to be profitable ventures for the publishers but Edward Finden was keen to expand on the range of illustrated material and in 1836, along with the publisher John Murray, brought out his *Landscape Illustrations to the Bible*. In his introduction to the work, he comments on the Bible's previous neglect; 'Little . . . has been done towards illuminating the most important of all books – The Holy Scriptures'.

Edward, with his brother William, had worked with Turner previously on *Byron's Life and Works*. They were among the most popular and prolific engravers of the nineteenth century and, like the Cookes, were also publishers. In about 1832 they invited Turner to produce twenty-six watercolours as part of the series of small plates of Bible scenery which were to be issued in parts and later in a two-volume edition of *The Biblical Keepsake* or *Landscape Illustrations of the Most Remarkable Places mentioned in the Holy Scriptures*. Other artists such as Clarkson Stanfield and Callcott also provided illustrations and the engravings were executed between 1833 and 1836.

Since Turner had never visited the Holy Land, he had to rely on sketches made on the spot by other artists, often amateurs. He seems to have been happy to use

such material from which to work up his watercolours, just as he had in the past for such projects as Hakewill's *Italy* (1818–20) and the Byron illustrations (1832–4).

Turner and the other artists would choose the sketches of subjects which most suited them and would make outline tracings before transforming them into finished watercolours to be engraved. The publishers therefore obtained accurately represented views of the scenery but profited from the popularity and superior ability of the artists employed. This view is based on sketches by the architect, Sir Charles Barry, whose drawings Turner seems to have preferred to those of the other amateur artists; he must have been particularly attracted to Barry's views of Jerusalem for he chose six, including this one. Ruskin made the perceptive observation that although Turner was depicting places unknown to him, he 'never drew anything that could be seen without having seen it. That is to say, though he would draw Jerusalem from someone else's sketch, it would be, nevertheless, entirely from his own experience of ruined walls' (*Works*, XIII, p.42).

JOHN COUSEN (1804–1880) AFTER
J.M.W. TURNER

81 **View near Jubbera** 1840
for White's *Views in India*
Engraving, later state (R.609): 127 × 128; 193 × 267 (trimmed within plate-mark)
Engraved inscriptions: below, with names of artist and engraver and 'DRAWN FROM NATURE BY G.F. WHITE, ESQ.'; centre 'VIEW NEAR JUBBERA.' / *Himalaya Mountains*; bottom, 'FISHER, SON & CO. LONDON & PARIS, 1840'
T05179

Turner produced seven designs for *Views in India chiefly among the Himalayan Mountains* by Lieut. G.F. White,

published in 1838. The drawings were engraved in 1836 by Cousen, Goodall and others. White himself provided the sketches for Turner to develop for the engravers since the artist had never visited India. According to Thornbury (1862, I, p.230), however, Turner may have been planning to accompany one of his patrons, Hugh Munro of Novar, to India at about this time, perhaps prompted by an increased knowledge of the country which he gained while working on this project.

White describes the scene depicted here as 'a peculiarly beautiful spot, where we found our breakfast laid out. . . It was a platform of rock, scooped by the hand of nature in the precipitous side of a shaggy mountain: above our heads crag piled itself upon crag, the interstices being richly clothed with foliage. . . In front and all around, we looked upon a chaotic confusion of hills, some separated from us and from each other by narrow and deep ravines and some running in long ridges throwing out what appeared to be endless ramifications'.

ILLUSTRATIONS FOR CAMPBELL'S POEMS (cat.nos.82–3)

Edward Moxon's 1837 edition of the *Poetical Works of Thomas Campbell* was the last important book that Turner illustrated, concluding several years of remarkable activity in poetry illustration. Twenty vignettes were published and a further design, 'The Drowning Slave' (R.633), was also engraved although was never published.

The circumstances surrounding the commission are extremely confused. Goodall's version (*Reminiscences*, 1902, p.44) states that Turner was to have been paid £30 for each design with a half share in the profits. Because of problems with the engraver's contract which Goodall believed would land him in severe financial difficulties, he persuaded Turner to lease the drawings to the publisher at £5 each, Turner thus retaining possession of them. Turner supposedly remarked 'This is the greatest act of generosity I have ever done in my life'. On the other hand, Campbell's biographer states that the poet bought the watercolours for twenty-five guineas each, having been told that they were like 'bank notes' and would always fetch the price paid (Beattie, 1849, III, p.337). On being short of money and wanting to realise his investment, Campbell attempted to sell them but could find no buyers. In about 1842, he met Turner by chance who bought them back from him for 200 guineas. This second version seems to chime more accurately with Turner's character but both stories

demonstrate the type of problem which often occurred between Turner and his publishers. Campbell decided to employ William Harvey to illustrate the next edition, in the hope of avoiding similar difficulties.

R. WALLIS AFTER J.M.W. TURNER

82 **'Sinai's Thunder'** 1837
for Campbell's *Poetical Works* ('The Pleasures of Hope', p.31)
Engraving, india proof (R.616): vignette, 103 × 74; 436 × 300; 294 × 153
Engraved inscriptions: below, with artist's name and *Wallis Proof*
T04768

The many designs which Turner provided specifically as illustrations to the writings of authors such as Campbell no doubt reflected his own interest in poetry. His fragmented manuscript poem, 'The Fallacies of Hope', makes ironic allusion to Campbell's poem *The Pleasures of Hope*, for which 'Sinai's Thunder' was one of four illustrations by the artist. The subject of 'Hope' obviously interested Turner but his attitude to it contrasted with that of Campbell who lays the emphasis on its various blessings, such as in this illustration, the hope offered by God.

This dramatic and emblematic view of 'Sinai's Thunder' was worked up from sketches drawn on the spot by Henry Gally Knight which had already been used by Turner for one of the Bible illustrations he made for Finden (w.1238; see also cat.no.80). Turner combines a naturalistic landscape with a conventional depiction of the figure of God, amid clouds, thunderbolts, and other religious symbols.

The engravers, like Turner, were allocated a number of proof impressions for each plate (see cat.no.7) which are sometimes referred to as 'Presentation Proofs' since they were probably given as gifts by the engravers; this engraving, inscribed 'Wallis proof', was clearly such an impression.

E. GOODALL AFTER J.M.W. TURNER

83 **Camp Hill, Hastings** 1837
for Campbell's *Poetical Works* (p.216)
Engraving, touched engraver's proof a) (R.629): vignette, 80 × 73, 436 × 301; 294 × 153
Inscribed by Turner: 'More pointed rays, starlike' [sketch], 'Little figures / army marching up', 'Ground Shadows too many / Shields the strongest'
T04781

The watercolours for Campbell's *Poetical Works* closely anticipated the engravings in size and were executed in brilliant colour, with tight, controlled brush strokes. Campbell referred to them as 'bits of painted pasteboard', perhaps in his annoyance at finding them hard to sell, but the watercolours (all in the National Gallery of Scotland; w.1271–90) are now considered to be some of the most beautiful of all Turner's watercolour illustrations. The vibrant colour was translated with great skill by the engravers, following the tonal variations closely. However Turner, as always, carefully supervised the engraving; on this proof he has

written his instructions for Goodall, correcting such motifs as the sun's rays. The device of the foreground shields, requiring stronger shadows, is similar to that used for the title-page of the *Provincial Antiquities of Scotland* (R.189).

Campbell climbed to the summit of Camp Hill one evening and imagined it on the night before the Battle of Hastings. His poem, 'Lines on the Camp Hill, near Hastings' described the scene: ''Oer Hauberk and helm, As the sun's setting splendour was thrown, Thence they looked o'er a realm. And tomorrow beheld it their own.'

85 **Study for Vignette** *c.*1832?
Watercolour and pencil
Turner Bequest; CCLXXX 82
D27599

Like cat.no.84, this drawing is not obviously related to a finished vignette illustration but could possibly be a study for 'Tornaro' for Rogers's *Poems* (TB CCLXXX 172). Both studies are so similar in execution that they must have been drawn around the same time and probably for the same project; they are sometimes cited as being related to the Campbell vignettes but this seems unlikely given their differing approach to composition and colour.

Both studies were drawn on a thin card which Turner frequently used while working on his vignette illustrations. Turner's method of working here, in bold areas of contrasted colour, corresponds exactly to the studies he used in planning his much larger watercolours, known as 'colour beginnings', in which the whole composition is reduced to blocks of elementary colour (see cat.no.15). The strongly contrasting tones of the red and yellow show that, from the outset, Turner was thinking of the need for them to be interpreted by the engravers into black and white.

84 **Study for Vignette** *c.*1832?
Watercolour and pencil
Turner Bequest; CCLXXX 77
D27594

The two pencil and watercolour studies shown here (see also cat.no.85) are either preliminary studies or unfinished vignette illustrations. Neither can be related with any certainty to a finished design but this study bears similarities to the views of Sandy Knowe or Smailholme Tower executed as illustrations to Scott (such as W.1140). Both studies provide a remarkable demonstration of the way Turner's vignettes were constructed, both in terms of colour and compositional format. This composition is built on a very simple, single motif which gives it unity and dramatic immediacy. If this were the basis for a finished watercolour rather than an exploratory preliminary study, it would be worked up with a mass of meticulous, fine, feathery strokes of the brush until it was crammed with intricate detail.

LARGE SINGLE PLATES
(cat.nos.86–88)

The majority of Turner's work translated into engraved form was produced by the artist specifically to be published in series, such as those for topography or literature. However, a certain number of single plates were also published after Turner, translations either of his oil paintings or of substantial exhibition watercolours.

It was through these important large engravings, as much as the hundreds of plates for series that, in the days before public art galleries, Turner was so well-known in his own day. Since the artist was well aware that it was only through these prints that most people would come to know his paintings, he devoted much time and energy supervising the quality of their engraving, to ensure they would be worthy of the originals; that of 'Modern Italy' (R.658) by Miller, for instance, is the subject of a lengthy correspondence between the artist and engraver, showing Turner's extraordinarily detailed comments and persistent criticisms (see Gage, 1980, no.246). It is therefore something of an irony that, today, the prints are often regarded as mere 'reproductions' of his paintings and are accordingly given scant attention.

The earliest of these large plates was the mezzotint of the 'Shipwreck' (cat.no.28); despite its success, other large plates were not executed until the copper-plate engraving of 'High Street, Oxford' in 1812 (R.79), which was followed by another 'View of Oxford from the Abingdon Road' in 1818 (R.80). Turner obviously realised the importance of these engravings at this early stage of his career for there also exists a fascinating correspondence between him and the Oxford dealer and publisher, James Wyatt, concerning the details of the 'High Street, Oxford' (Gage, 1980, pp.35–43 *passim*).

In 1822, Turner was planning an ambitious series of four plates from his own paintings to rival the large engravings by William Woollett after Richard Wilson. Turner proposed several of his earlier pictures as possible subjects such as 'Snowstorm: Hannibal and his Army crossing the Alps (B&J 126, Gallery 107) and 'Dido and Aeneas' (B&J 129, Gallery 106) but the project evidently fell through (Gage, 1980, no.97). The majority of these ventures to engrave single large plates were proposed by printsellers; this 1822 project was instigated by Hurst and Robinson, and the prints were intended to be published by subscription, as had been the case for the 'Shipwreck' (see cat.no.29).

Between 1824 and 1828, four large copper-plate engravings were published; 'Ehrenbreitstein' (R.202), 'Cologne' (R.203), 'Tivoli' (cat.no.86) and 'The Temple of Jupiter Panhellenius in the Island of Aegina' (R.208). The engraving of 'Tivoli' proved a financial failure for its publishers (see cat.no.86) and this may also have been the case with the other three. In addition, eight large mezzotints (R.791–8) were engraved, mostly between 1828 and 1830, including 'The Deluge' (cat.no.56) and the 'Field of Waterloo' (R.795), but many of them seem to have remained unpublished. Whatever the reason for the lack of success with these large plates in general, Turner was deterred from attempting similar ventures for several years to come.

From about 1840, the sale of illustrated books slowed down and the public began to want large prints as had been the tradition in the eighteenth century. To meet this demand, Turner embarked on a series of large plates which appeared at intervals from 1838 onwards. Many of these were translations of his most important paintings and seem to represent the pinnacle of his achievement in the field of engraving.

In March 1842, five large copper-plate engravings (R.652–6) were advertised in the *Art Union*, including 'Caligula's Palace' (cat.no.87). This project may have been a revival of the 1822 proposal although the choice of paintings to be engraved was different and included earlier pictures such as 'Crossing the Brook' (B&J 130, Gallery 106), as well as more recent paintings. These five carefully chosen subjects were calculated to underline Turner's status as a painter in the classical tradition of European landscape and were intended to be seen as worthy successors to the great prints of the eighteenth-century engravers such as Woollett. The importance Turner attached to this project is demonstrated by the fact that he took the risk of publishing the prints at his own expense (under the name of his agent, Thomas Griffith, see cat.no.87), the first time he had done so since the *Liber Studiorum*.

Nearly twenty other large line engravings were executed in Turner's last years. Other important large plates, some of which had been planned or commenced during Turner's lifetime, were published after his death in 1851 (R.671–689). These large plates were mainly executed by engravers who had worked with Turner; they appeared at intervals up to 1874. Many of them, such as Wallis's 'Approach to Venice' (R.679), are fine prints and show that the engravers' long experience under Turner's supervision enabled them to reproduce the spirit of his pictures, although the lack of the artist's expert hand to direct and correct them certainly shows.

Many of Turner's paintings became known to the public after his death when they were engraved for *The Turner Gallery*. Although small, these plates were also usually translations of Turner's most famous oil pic-

tures, although a few watercolours were included as well. Approximately sixty plates were issued in sets between 1859 and 1861, accompanied by a text by Ralph Wornum; a further edition was issued in 1875 with a few alterations. Although published nearly ten years after Turner's death, many of the plates were engraved by Turner's old engravers so the general standard was high but, like the posthumous large plates, they lack the clarity, force and accent which Turner would have imposed.

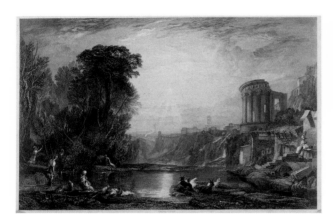

E. GOODALL AFTER J.M.W. TURNER

86 **Tivoli, A Composition** 1817
Engraving, india proof (R.207): 404 × 605;
430 × 638 (trimmed within plate-mark)
Engraved inscriptions: below, with *Etched by E. Goodall*
T04502

This state, not listed by Rawlinson, appears to be an early engraver's proof, probably the first to be taken after the preliminary etching. It is still inscribed with the underline 'Etched by E. Goodall' which has been erased in the engraver's proof a), the first to appear in Rawlinson.

A very carefully executed squared-up preparatory drawing in the British Museum (1891-4-14-71), presumably by Goodall, shows the care which was taken in making an accurate and faithful copy of the original. Goodall executed very few large plates; 'Tivoli' was his first endeavour, and this was followed in the early 1840s by two other large plates, one of which was 'Caligula's Palace and Bridge' (cat.no.87). 'Tivoli' was privately published by Goodall in conjunction with John Allnutt, a patron of Turner for whom the work was commissioned, but it failed to find subscribers; Allnutt apparently lost £400 (Beck, 1973, p.26).

The large watercolour on which this engraving was based is now in a private collection (W.495), although there is a preliminary colour study for the composition in the Turner Bequest (CXCVII A); it was made as a pair to the 'Rise of the River Stour at Stourhead' (W.496).

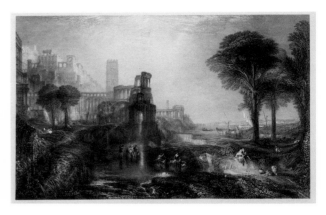

E. GOODALL AFTER J.M.W. TURNER

87 **Caligula's Palace and Bridge** 1842
Engraving, first published state on india paper
(R.653): 394 × 615; 657 × 850; 540 × 715
Engraved inscriptions: below, with names of artist and engraver; bottom, 'LONDON: PUBLISHED JUNE 23.RD 1842, BY THO.S GRIFFITH, ESQ.RE 14, WATERLOO PLACE, FOR J.M.W. TURNER, R.A.'
T04789

The painting on which this print is based is in the Tate Gallery (B&J 337; Reserve Gallery 2). Rawlinson relates (1908-13, II, p.337), that 'after [Goodall] had commenced the engraving, it had to be heightened some inches, and [he] employed an architect to draw the necessary alterations to the buildings. On seeing them, Turner said that more figures would now be required and drew several men and animals loosely, in white chalk, on the picture. Goodall declared that he was quite unable to engrave from these slight sketches and Turner accordingly drew the figures himself in watercolour on the picture'. Despite the many difficulties Goodall must have had while engraving this plate, he was paid 700 guineas for it which shows the great appreciation Turner must have had for his work.

Goodall's son also recalls a conversation between Turner and the engraver which probably occurred during the engraving of this plate and which gives us some insight into Turner's attitude towards teaching his engravers about the translation of colour into black and white: 'My father once asked how he should translate a piece of brilliant red in one of Turner's pictures [possibly the boy's cap in 'Caligula's Palace']. He answered, "Sometimes translate it into black and at another time into white. If a bit of black gives the

emphasis, so does red in my picture. And in the case of translating it into white'', he said after brief reflection, "put a grinning line into it that will make it attractive"' (*Reminiscences*, 1902, p.57).

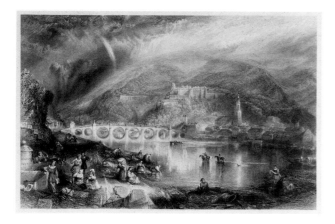

T.A. PRIOR (1809–86) AFTER J.M.W. TURNER

88 **Heidelberg from the Opposite Bank of the Neckar*** 1846
Engraving, first published state on india paper
(R.663): 369 × 545; 666 × 856; 563 × 700
Engraved inscriptions: below, with name of engraver and date and 'PUBLISHED BY T.A. PRIOR, 3, ELIZABETH PLACE, UPPER ROAD, PUTNEY, JUNE 1.ST 1846.'
T05190

Many of the large plates (such as 'Caligula's Palace', cat.no.87) were engraved on copper until as late as 1845, even though the use of steel was by then more or less universal. The engravers found steel plates too laborious to work on such a large scale and faults were more difficult to correct, not to mention Turner's frequent alterations to his own designs. The large steel plates would take as long as two or three years to engrave and therefore necessitated a high salary for the engravers; and Turner may have come to feel that such large payments, and the time and effort he devoted to their publication, were not in the end justified.

Many of the late large steel engravings, such as this, were based on Turner's late Swiss and continental watercolours such as 'Oberwesel' (R.660), 'Zurich' (R.672) and 'Lake of Lucerne' (R.671), in which Turner returned to formal and historical themes; the figures in this engraving, for instance, appear in medieval costume. The dignity of this composition is typical of these late large watercolours and it is imbued with intricate atmospheric effects and quivering light which have been brilliantly captured in the engraving.

Heidelberg was a subject treated many times by Turner, both in watercolour and in the painting of 'Heidelberg in the Olden Time' (B&J 440, Gallery 101). This version was supposedly executed in *c*.1841 at the suggestion of the engraver, T.A. Prior, who had applied to Turner for a commission and 'having been attracted by Heidelberg on a recent visit, he suggested that subject to Turner. The painter at first discouraged [Prior] as his large engravings had not latterly been selling well, but on reflection he yielded and promptly made the 'Heidelberg' drawing from a sketch of Prior's, charging the latter 100 gs. for it' (Rawlinson, 1908–13, II, p.343). Although the story seems unlikely since Turner drew Heidelberg on many other occasions, it may perhaps be confirmed by the existence of an unusual colour study in the Turner Bequest (CCCLXV 34), which is partially annotated and coloured and carefully plotted out in detail as though Turner was feeling his way with an alien theme.

Turner seems to have only once touched a proof of 'Heidelberg' during the course of its engraving; such restraint was, as we have often seen, extremely unusual and no doubt demonstrates his great satisfaction with the plate which justifiably greatly enhanced Prior's reputation.

Bibliography

All books published in London unless otherwise stated.

Alfrey, N. (*et.al.*), *Turner en France*, exhibition catalogue, Centre Culturel du Marais, Paris, 1982

Bain, I., 'Thomas Ross & Son', *Journal of the Printing Historical Society*, 1966, 2, pp.3–21

Baltimore Museum of Art, *J.M.W. Turner: Illustrations for Books*, exhibition catalogue, Baltimore, 1975

Beattie, W., *The Life and Letters of Thomas Campbell*, 1849

Beck, H., *Victorian Engravings*, exhibition catalogue, Victoria & Albert Museum, London, 1973

Bell, C.F., 'Turner and his Engravers' in *The Genius of J.M.W. Turner* ed. Charles Home, 1903

Butlin, M. & E. Joll, *The Paintings of J.M.W. Turner*, 2 vols, 1984 (revised edition)

Cleveland Museum of Art, *Dreadful Fire!*, exhibition catalogue, Cleveland, Ohio, 1984

Colnaghi, *Turner's Liber Studiorum*, exhibition catalogue, London, 1975

Dawson, B., *Turner in the National Gallery of Ireland*, Dublin, 1988

Dyson, A., *Pictures to Print: the Nineteenth Century Engraving Trade*, 1984

Finberg, A.J., *A Complete Inventory of the Drawings of the Turner Bequest . . .*, 2 vols, 1909

Finberg, A.J., *The History of Turner's 'Liber Studiorum'*, 1924

Finberg, A.J., *Turner's 'Southern Coast'*, 1929

Finberg, A.J., *The Life of J.M.W. Turner*, 1961 (2nd edition)

Finley, G., *Landscapes of Memory: Turner as Illustrator to Scott*, 1980

Fitzwilliam Museum, *The Print in England, 1790–1930*, exhibition catalogue, Cambridge, 1985

Gage, J., *Colour in Turner: Poetry and Truth*, 1969

Gage, J. (ed.), *The Collected Correspondence of J.M.W. Turner*, 1980

Gage, J., *J.M.W. Turner: 'A Wonderful Range of Mind'*, 1987

Gage, J., 'Turner and John Landseer: Translating the Image', *Turner Studies*, 1988, vol.8, no.2, pp.8–12

Goodall, F., *Reminiscences of Frederick Goodall R.A.*, 1902

Grand Palais, *J.M.W. Turner*, exhibition catalogue, Paris, 1983–4

Griffiths, A., *Prints and Printmaking*, 1980

Hamerton, P.G., *Etching and Etchers*, 1880

Hamlyn, R., 'An early Sketchbook by J.M.W. Turner', *Record of the Art Museum, Princeton University*, 1985, vol.44, no.2, pp.2–23

Haringey Libraries, Bruce Castle, *J.M.W. Turner: Engraved Work from Con. McCarthy's Collection*, London, 1972

Hayes, J., *Gainsborough as Printmaker*, 1971

Herrmann, L., *Turner Prints: the Engraved Work of J.M.W. Turner*, Phaidon, forthcoming autumn 1990

Hill, D., *In Turner's Footsteps*, 1984

Holcomb, A., 'The Vignette and the Vortical Composition in Turner's oeuvre', *Art Quarterly*, 1970, vol.32, no.1, pp.16–29

Hunnisett, B., *Steel-Engraved Book Illustration in England*, 1980

International Exhibitions Foundation, *Turner Watercolours from the British Museum*, exhibition catalogue, 1977–8

Joll, E., 'Turner at Dunstanborough 1797–1834', *Turner Studies*, 1988, vol.8, no.2, pp.3–7

Lambert, S., *The Image Multiplied*, exhibition catalogue, Victoria & Albert Museum, London, 1987

Miller, T. (ed.), *Turner and Girtin's Picturesque Views of English, Scotch and Welsh Scenery a Hundred Years Ago*, 1873

National Gallery of Scotland, *Turner's Illustrations for the Poetical Works of Thomas Campbell*, exhibition leaflet, Edinburgh, 1988

Omer, M., *Turner and the Poets*, exhibition catalogue, Marble Hill House, London, 1975

Omer, M., *Turner and the Bible*, exhibition catalogue, Israel Museum, Jerusalem, 1979

Petter, H.M., *The Oxford Almanacks*, Oxford, 1974

Powell, C., 'Turner's Vignettes and the making of Rogers's Italy', *Turner Studies*, 1983, vol.3, no.1, pp.2-13

Powell, C., *Turner in the South*, 1987

Pye, J. & J.L. Roget, *Notes and Memoranda respecting the 'Liber Studiorum' of J.M.W. Turner, R.A. written and collected by the late John Pye . . . edited with additional observations . . . by John Lewis Roget*, 1879

Rawlinson, W.G., *Turner's 'Liber Studiorum'*, 1878 (1st edition)

Rawlinson, W.G., *The Engraved Work of J.M.W. Turner*, 2 vols, 1908-13

Royal Academy of Arts, *Turner 1775-1851*, catalogue of Bicentenary exhibition, London, 1974-5

Ruskin, J., *Works* (Library Edition), ed. E.T. Cook and A. Wedderburn, 39 vols, 1903-12

Shanes, E., *Turner's Picturesque Views in England and Wales*, 1979

Shanes, E., *Turner's Rivers, Harbours and Coasts*, 1981

Shanes, E., 'New Light on the *England and Wales* series', *Turner Studies*, 1984, vol.4, no.1, pp.52-4

Shanes, E., *J.M.W. Turner: the Foundations of Genius*, exhibition catalogue, Taft Museum, Cincinatti, 1986

Thornbury, W., *The Life of J.M.W. Turner R.A.*, 2 vols, 1862 (1st edition)

Venning, B., 'A Macabre Connoisseurship: Turner, Byron and the Apprehension of Shipwreck Subjects in Early Nineteenth-Century England', *Art History*, 1985, vol.8, no.3, pp.303-19

White, C., *English Landscape 1630-1850*, exhibition catalogue, New Haven, Yale, 1977

Whittingham, S., 'A Most Liberal Patron: Sir John Leicester, Bart., 1st Baron de Tabley, 1762-1827' *Turner Studies*, 1986, vol.6, no.2, pp.24-36

Wilkinson, G., *Turner's Colour Sketches 1820-1834*, 1975

Wilkinson, G., *Turner on Landscape: the 'Liber Studiorum'*, 1982

Wilton, A., *The Life and Work of J.M.W. Turner*, 1979

Wilton, A., *Turner and the Sublime*, exhibition catalogue, pub. British Museum, 1980-1

Wilton, A., *Turner in his Time*, 1987

Sale catalogues of Turner engravings from the artist's collection: Christie's, London; March 24-28, 1873; April 23-25, 1873; June 24-27, 1873; March 3-7, 1874; May 27, 1874; and July 23-24, 1874